# I CAN DRAW **COMICS**

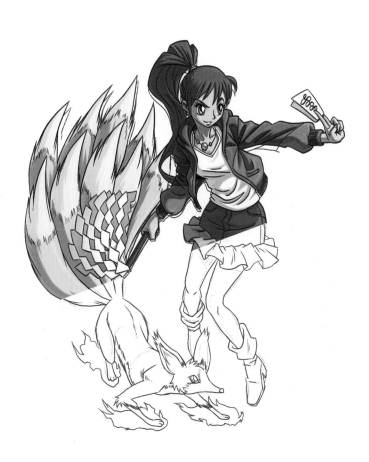

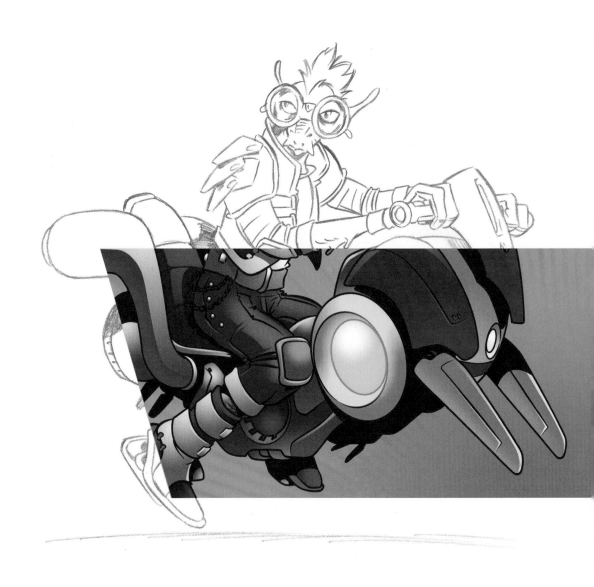

# I CAN DRAW **COMICS**

## STEP-BY-STEP TECHNIQUES, CHARACTERS AND EFFECTS

**WILLIAM POTTER**
**JUAN CALLE**
**STEVE SIMS**

**SIRIUS**

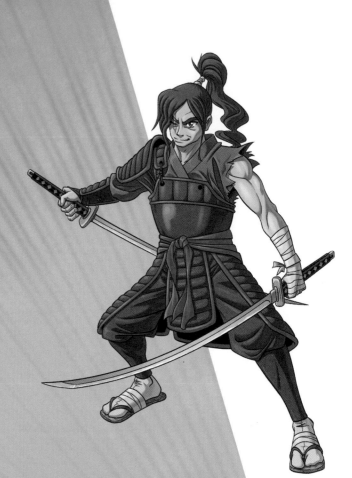

SIRIUS

This edition published in 2024 by Sirius Publishing, a division of
Arcturus Publishing Limited,
26/27 Bickels Yard, 151–153 Bermondsey Street,
London SE1 3HA

ISBN: 978-1-3988-3630-3
AD011377US

Printed in China

# CONTENTS

# INTRODUCTION

Whether you're a complete beginner or a superhero of comic illustration, this book will help you to take things to the next level. Follow the expert step-by-step guides to create characters and scenes across five different comic art genres.

### SUPERHERO COMICS

Superheroes first exploded onto the American comics scene in the 1930s and 40s. Superman, the first of these larger-than-life characters, arrived in *Action Comics* #1 in 1938. Superheroes made such a huge impact on the medium that today, many people equate comics with superhero stories.

### FANTASY COMICS

Comics are the perfect medium for fantasy adventures, since artists don't need to worry about special effects budgets. The number of exotic locations and weird creatures featured in a story are limited only by the storyteller's imagination! Get ready to unleash a whole army of orcs, trolls, and dragons on your unsuspecting readers.

### SCIENCE FICTION COMICS

Science fiction comics were very popular in the 1930s, and it was from this genre that superheroes emerged. Sci-fi comics have continued to be especially popular in the UK, where comic fans thrill to the weekly adventures of futuristic antiheroes such as Judge Dredd.

### HORROR COMICS

Horror comics with fantastic names like *Vault of Horror* or *Tales from the Crypt* were hugely popular in the 1940s and 50s. Comics can't make people jump with a bang, like a movie can. However, a talented artist can create an eerie and sinister atmosphere that will chill readers to the bone.

### MANGA COMICS

Manga isn't really a genre so much as a nationality, since all comics from Japan fall into this category. Modern manga first emerged after World War II, during the American occupation of Japan. The style was initially influenced by American cartoonists such as Walt Disney, but it has since developed an entirely unique approach.

# HOW TO USE THIS BOOK

This book will take you through the process of creating comic book characters and show you how to get them into action. Most drawings are broken down into a series of steps, as set out below.

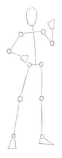

**1** The basic stick figure of your character.

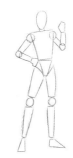

**2** Fleshing out the basic stick figure.

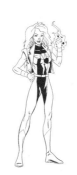

**5** Using ink to sharpen your drawing.

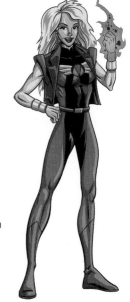

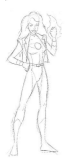

**3** Completing the outline drawing of your figure.

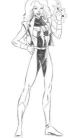

**4** Pencil shading to define the figure.

**6** Adding color to complete the figure.

## PRACTICE PAGES

At the end of each exercise, you will find a grid with an outline figure or a space for you to practice your skills. With character drawing, a basic wireframe outline is given, so you can add your own details on top of it. At the end of each chapter there is space for you to practice a larger scene, following the steps in the previous pages.

# THE BASICS

You don't need lots of expensive equipment to start creating comics.
The most important tool is your own imagination!

## LAYOUT PAPER

Artists, both as professionals and as students, rarely produce their first practice sketches on their best quality art paper.

It's a good idea to buy some inexpensive plain Letter paper (or a larger format if you prefer) from a stationery shop for all of your practice sketches.

Most professional illustrators use cheaper paper for basic layouts and practice sketches before they get round to the more serious task of producing a masterpiece on more costly material.

## CARTRIDGE PAPER

This is heavy-duty, quality drawing paper, ideal for your final version. You don't have to buy the most expensive brand. Most decent art or craft shops stock their own brand or a student range and, unless you're thinking of turning professional, these will do fine.

## WATERCOLOR PAPER

This paper is made from 100 per cent cotton, and is much higher quality than wood-based papers. Most art shops stock a large range of weights and sizes. 250 gsm or 300 gsm are fine.

## LINE ART PAPER

If you want to practice black and white ink drawing, line art paper enables you to produce a nice clear crisp line. You'll get better results than you would on cartridge paper as it has a much smoother surface.

## CIRCLE TEMPLATE

This is very useful for drawing small circles.

## FRENCH CURVES

These are available in a few shapes and sizes and are useful for drawing curves.

## ERASER

There are three main types of eraser: rubber, plastic, and putty. Try all three to see which kind you prefer.

## PENCILS

It's best not to cut corners on quality here. Get a good range of graphite (lead) pencils ranging from soft (6B) to hard (6H).

Hard lead lasts longer and leaves less graphite on the paper. Soft lead leaves more lead on the paper and wears down more quickly. Every artist has their personal preference, but 2H pencils are a good medium range to start out with until you find your favorite.

Spend some time drawing with each weight of pencil and get used to their different qualities. Another good product to try is the clutch, or mechanical pencil. These are available in a range of lead thicknesses and are very good for fine detail work.

## BRUSHES

Some artists like to use a fine brush for inking linework. A no. 3 sable brush can be used to achieve a variety of line thicknesses. See the exercise on pages 20–3 for more on the process of inking and coloring.

## MARKERS

These are very versatile pens and, with practice, can give pleasing results.

## PENS

There are many good quality pens available in a range of nib thicknesses, including "superfine," "fine," and "brush." The "brush" nib pens are very good as they produce a good range of line thicknesses. You may find that you end up using a combination of pens to create your finished piece of artwork. Remember to use a pen that has watertight ink if you want to color your illustration with a watercolor or ink wash. It's quite a good idea to use one of these anyway. There's nothing worse than having your nicely inked drawing ruined by an accidental drop of water!

## INKS

With the dawn of computers and digital illustration, materials such as inks have become a bit obscure, so you may have to look harder for these but most good art and craft shops should stock them.

# MALE FIGURES: PROPORTIONS

Your comic characters may come from your imagination, but their body shapes will be based on reality. Here are some rules for proportions that you can use as a guide when drawing.

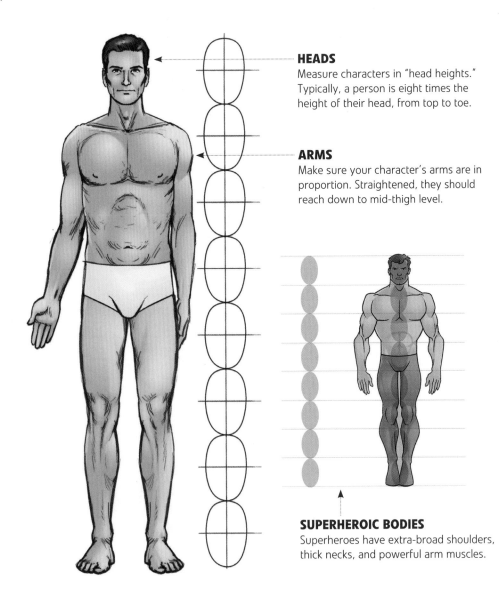

### HEADS

Measure characters in "head heights." Typically, a person is eight times the height of their head, from top to toe.

### ARMS

Make sure your character's arms are in proportion. Straightened, they should reach down to mid-thigh level.

### SUPERHEROIC BODIES

Superheroes have extra-broad shoulders, thick necks, and powerful arm muscles.

# FEMALE FIGURES: PROPORTIONS

Women have a more slender build than men, with muscles that are less defined. The neck is longer and the waist more pronounced. Female characters follow the same "eight heads" principle.

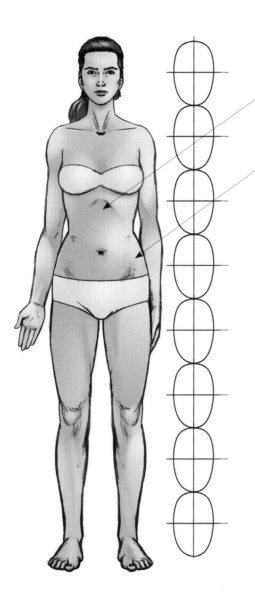

## TORSOS

The distance from shoulder to hips should be about two-and-a-half head heights.

## SHOULDERS AND HIPS

Female characters' hips and shoulders are similar in width. Males taper from broad shoulders to a more narrow waist and hips.

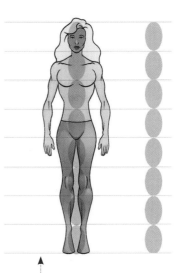

## SUPERHEROINES

Superheroines do not have such large muscles as male superheroes, but their shoulders are broader than real women's.

# HEAD PROPORTIONS

Faces have their own proportions, with eyes and ears about halfway down the head. Here are average male and female faces you can use for reference.

The ears are about the same height and position as the nose.

The eyes should be one eye-width apart. The nose forms a thin triangle that, if continued, touches the sides of the mouth.

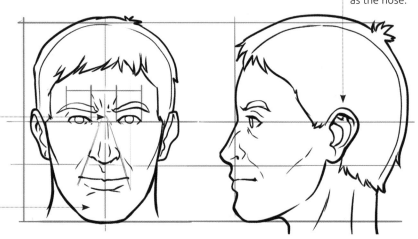

Male jaws tend to be wider and squarer than female jaws.

Women's noses tend to be smaller than men's. The eyebrows are drawn thinner and arched, while the lips are curvier.

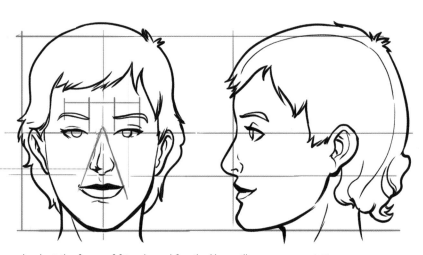

Look at the faces of friends and family. You will see many variations. Sketch details you see, and study hairstyles which you can use to make each of your comic characters unique.

# PRACTICE

Use the guidelines to practice
drawing heads in proportion.

# BUILDING A BODY

Here you can see how to build the human figure by starting with a stick figure, then adding to it using basic shapes. Whatever pose you want to draw your character in, once you have learnt this step-by-step technique, you'll have the skills you need to draw realistic-looking figures.

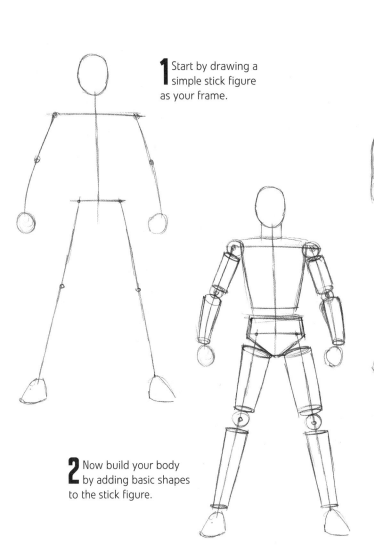

**1** Start by drawing a simple stick figure as your frame.

**2** Now build your body by adding basic shapes to the stick figure.

**3** Draw around the shapes to produce your figure outline. Once you have established your character's body shape, you can add details.

**PRACTICE**

# STRIKE A POSE

Here are the basics for drawing a hero in a dynamic pose, ready for action.

**1** Using light pencil marks, draw a simple stick figure showing your hero's pose, with circles for joints. Make the pose dramatic but be sure that the proportions are correct.

**2** Use basic shapes to fill out your figure: an oval head, a rounded torso that goes in toward the waist, and cylindrical arms and legs. The figure's left arm seems short but gets wider the closer it is to the viewer. This effect is called foreshortening.

**3** Add flesh to your hero. Replace the body blocks with more accurate anatomy, muscles, and joints. Reshape the hands and feet, adding fingers. Carefully erase your original construction lines.

# PRACTICE

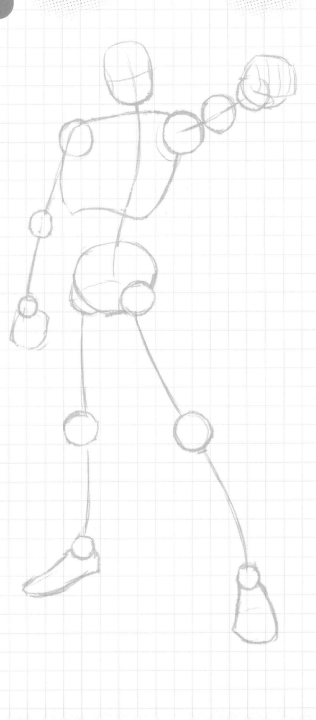

# RACING INTO ACTION

**Time to get your hero off the starting blocks. Here's how to draw a character running forward into action—heroes never run away from danger, of course!**

**1** This character leans dramatically in the direction she is racing, with her torso twisted almost at a right angle to her waist. Her left arm is pushing forward, while her left leg is behind, and vice versa for her right-hand limbs.

**2** With her body leaning over, we see her shoulders and chest from above, with her torso getting thinner to her waist. Just as on a real human body, the 3D shapes used to build her form are not straight, but slightly curved.

**3** As you tighten the pencils, you can define the muscles on the figure. The muscles on her left arm are slightly rounder than those on her right arm, as they pull her forearm up. Elbows and knees stand out more as the joints are bent.

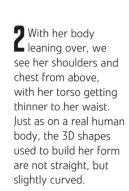

# PRACTICE

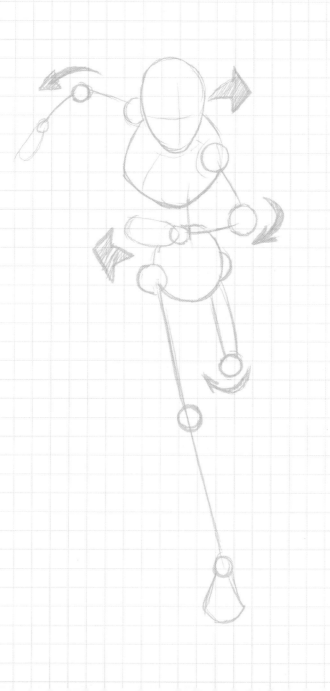

# INKING AND COLORING

You can really bring your pencil drawings to life by applying bold, black ink lines over the top, followed by vibrant colors. There are lots of ways in which you can apply color. Some artists use watercolors or gouache, others use inks or marker pens. This exercise uses a coloring method that can be applied with inks, marker pens, and watercolors.

You can choose how to ink your pencil drawing. Some artists prefer to use a brush and a pot of black Indian ink. We recommend you use watertight Indian ink, so that when you apply your color on top, your ink will not smudge.

A clean, crisp line style has been used to ink this character, but you may wish to experiment with different styles and textures of your own.

Practice using your pens or brushes to create lines of various thickness. The lines on this page were produced with a versatile "brush" nib pen.

Once you have inked your drawing, it's time to move on to the coloring. On the following pages we'll show you how to build up layers of color on top of your inked drawing. The key is to start by applying lighter colors as your base, then build up the color by adding layers of darker tones over the top. Layering colors like this gives a rich, tonal finish.

**1** Finish your pencil drawing, marking out any areas of shading to go over in solid, black ink.

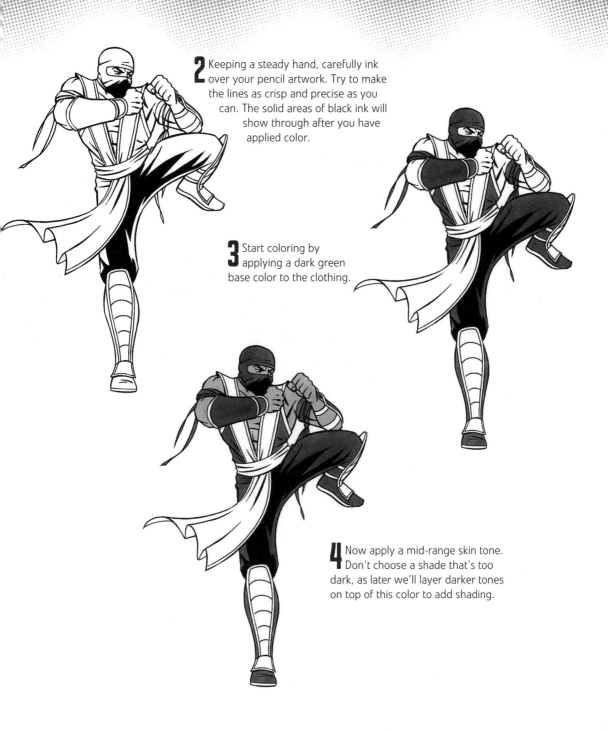

**2** Keeping a steady hand, carefully ink over your pencil artwork. Try to make the lines as crisp and precise as you can. The solid areas of black ink will show through after you have applied color.

**3** Start coloring by applying a dark green base color to the clothing.

**4** Now apply a mid-range skin tone. Don't choose a shade that's too dark, as later we'll layer darker tones on top of this color to add shading.

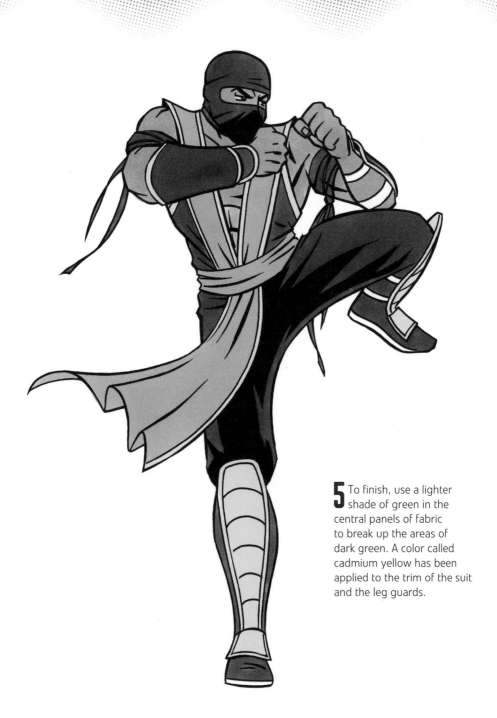

**5** To finish, use a lighter shade of green in the central panels of fabric to break up the areas of dark green. A color called cadmium yellow has been applied to the trim of the suit and the leg guards.

# PRACTICE

# PERSPECTIVE

Drawing in perspective is key to creating realistic settings for your comic book characters. Here's how to use perspective lines to draw city scenes from different viewpoints.

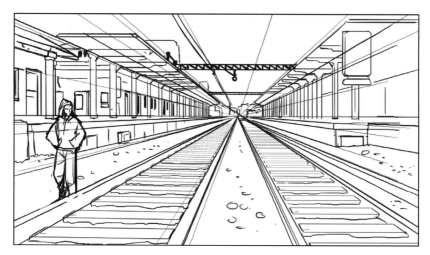

◀As objects get farther away, they appear smaller, like the rails on this track. The point at which the rail track disappears is called the **VANISHING POINT**. The horizontal line in the distance, at the viewer's eye level, is called the **HORIZON LINE**.

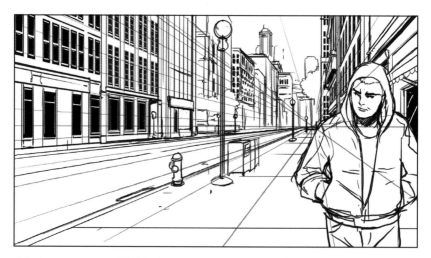

⬆ In this street scene, **PERSPECTIVE LINES** drawn from the vanishing point on the horizon are used as guides to draw buildings and windows at the correct angle. This is a **ONE-POINT PERSPECTIVE**.

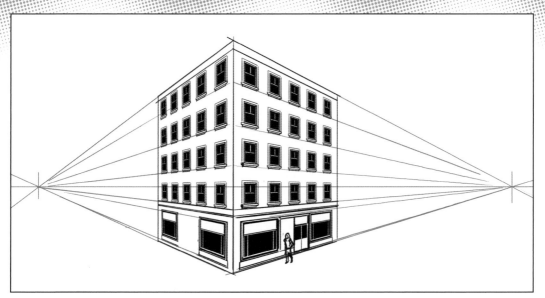

⬆ For this building, seen from a corner, the lines on the left and right disappear in different directions. These lead to two vanishing points, on either side. This is a **TWO-POINT PERSPECTIVE**.

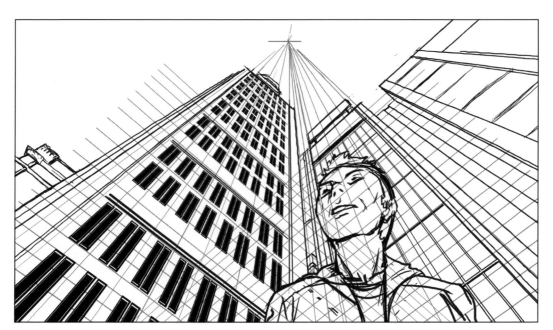

⬆ A dramatic **THREE-POINT PERSPECTIVE** is used here, where buildings are turned at different angles. The vertical perspective lines all point to the same vanishing point in the sky, but the horizontal lines cross one another to form a grid.

# SUPERHERO COMICS

Welcome to the pulse-pounding world of superheroes! In this chapter, you'll find step-by-step guides showing you how to draw two superheroes, then set them to work fighting a supervillain in an action scene.

What makes a great comics hero? It depends who you ask. Most of the superheroes of the Golden Age of Comic Books, from the 1930s to the early 1950s, were essentially wish-fulfilment characters. They had incredible powers, good looks, and plenty of moral fiber!

In the 1960s, flawed superheroes became popular. These characters' extraordinary abilities were offset by real-life problems, such as a hostile public, and character defects, such as arrogance. Some heroes saw their powers as a curse.

In the 21st century, many comic creators have tried to better represent the diversity of people in the modern world. By giving your characters varied backgrounds and interesting flaws and problems, you can make them feel compelling.

# CHARACTER INSPIRATION

If you're creating your own superhero comic, you might want to use your own superheroes or supervillains. Where can you find inspiration for new characters?

## NATURE HEROES

You can take your starting point from aspects of nature, such as clouds, rainbows, volcanoes, or plants.

Tanglevine's body is covered in tough, thorny armor. He can use the vines sprouting from his back to entangle his enemies.

## ANIMAL HEROES

One way to devise a new character is to take inspiration from an animal. Many superheroes, such as Batman and Spider-Man, have the characteristics and capabilities of animals.

Magpie is an excellent thief. Like real magpies, she has a love of shiny things—such as priceless jewels.

## STORYBOOK HEROES

Some comic characters are inspired by other fictional characters, such as the mythical god Thor or Robin Hood.

This savage superhero, the Scarlet Hood, is inspired by the story of Little Red Riding Hood. Like the heroine of that story, she wears a long red cloak. She also has the claws of a big, bad wolf!

## SCIENCE HEROES

Science, whether real or science fiction, provides excellent inspiration for comic book superpowers.

The Hologram is a robotic superhero inspired by real-life holograms and lasers. He can shoot light beams from his hands and create illusions.

# G-FORCE

Are you ready to draw your first superhero? Rocket scientist Todd Travis was building the warp drive of an experimental ship when the engine exploded. The cosmic energy gave him the ability to control gravity. Now he fights crime across the galaxy!

**1** It's important that you get the initial pose and proportions right. Sketch a wireframe showing limbs and joints.

**2** Use basic shapes to build on top of your wireframe. G-Force's hips are triangular, and his chest tapers to the waist. The leg that is closest to us looks slightly longer than the trailing leg.

**3** Now you can bulk up the body and outline where the features will go. Sketch in G-Force's leg and arm muscles, and define those in his stomach area. Round off the joints and add details to the hands and feet, including fingers and knuckles.

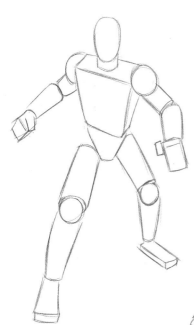

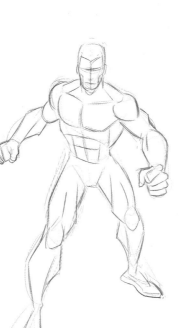

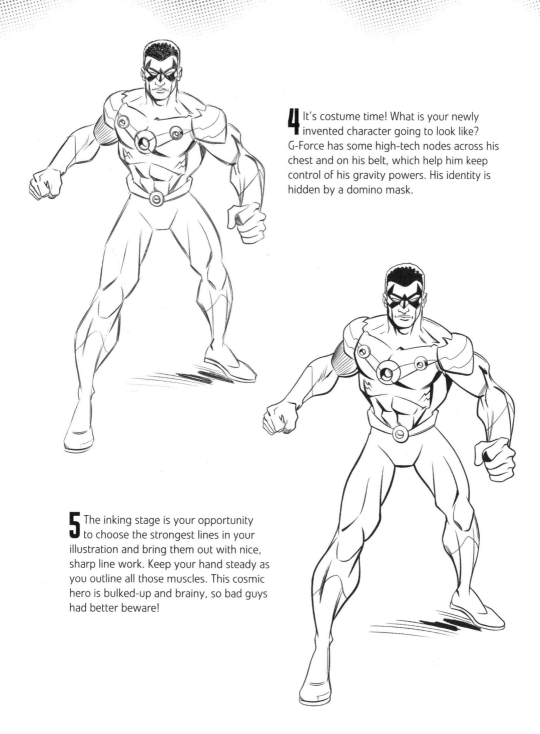

**4** It's costume time! What is your newly invented character going to look like? G-Force has some high-tech nodes across his chest and on his belt, which help him keep control of his gravity powers. His identity is hidden by a domino mask.

**5** The inking stage is your opportunity to choose the strongest lines in your illustration and bring them out with nice, sharp line work. Keep your hand steady as you outline all those muscles. This cosmic hero is bulked-up and brainy, so bad guys had better beware!

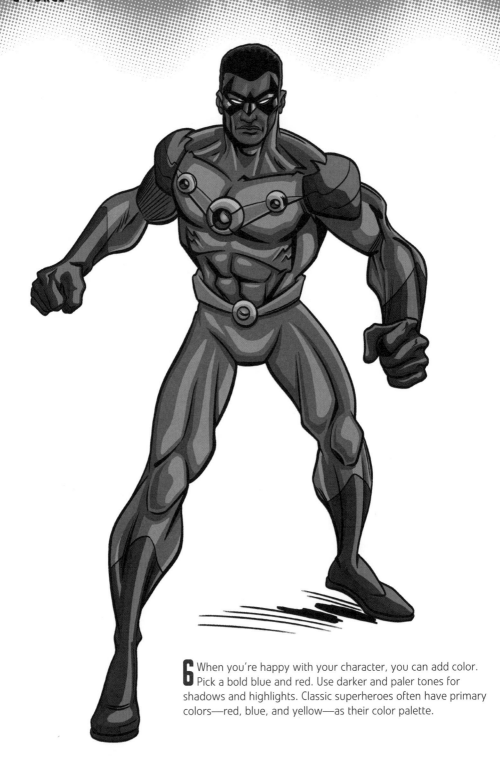

**6** When you're happy with your character, you can add color. Pick a bold blue and red. Use darker and paler tones for shadows and highlights. Classic superheroes often have primary colors—red, blue, and yellow—as their color palette.

**PRACTICE**

# VICTORY

Let's create another superhero. Secret military experiments have transformed former marine Vikki Ventura—a.k.a. Victory—into a human fighter plane. She can fly at supersonic speeds and fire blasts of energy from her fingertips.

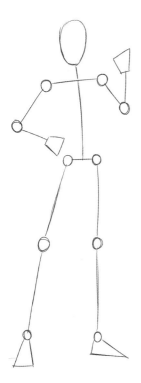

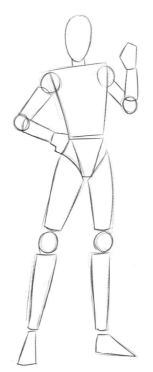

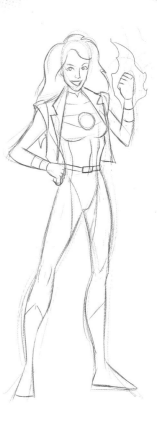

**1** Sketch the wireframe with a line for the shoulders and slightly narrower hips. Victory's raised hand is her weapon.

**2** Add the simple shapes that make up her body and limbs. Avoid using straight lines when you are drawing people. Slight curves give them more movement and poise.

**3** Begin to add the details of Victory's hair and face. Sketch your rough ideas for her costume, including wrist cuffs, belt, and boots. Add an outline of the power that she shoots from her clenched fist.

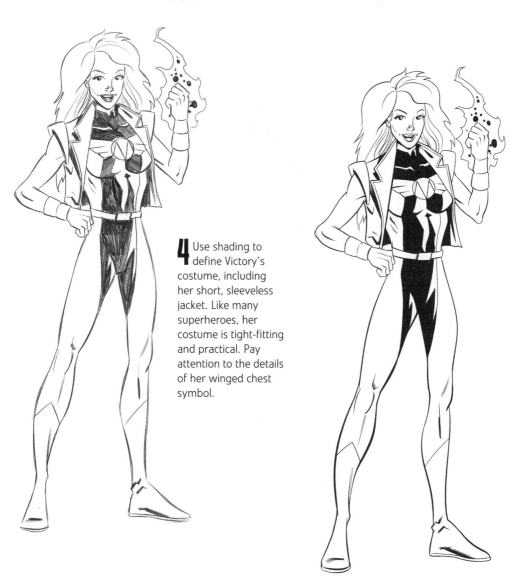

**4** Use shading to define Victory's costume, including her short, sleeveless jacket. Like many superheroes, her costume is tight-fitting and practical. Pay attention to the details of her winged chest symbol.

**5** Is Victory fighting on the side of good or evil? You can use the subtle details of her facial features to show her personality. Here, her face has been carefully inked to show an open, friendly expression. However, if you lower her eyebrows, she will look more sinister.

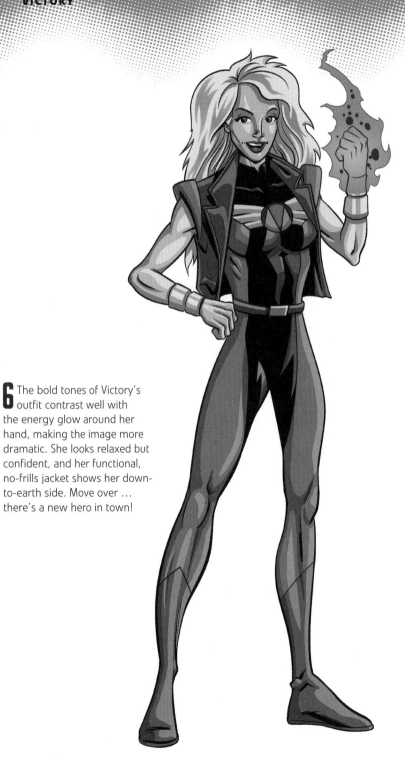

**6** The bold tones of Victory's outfit contrast well with the energy glow around her hand, making the image more dramatic. She looks relaxed but confident, and her functional, no-frills jacket shows her down-to-earth side. Move over … there's a new hero in town!

# PRACTICE

# KEY SKILL: TAKING OFF

How should you draw a flying character? Here is an electrically powered hero launching himself into the stratosphere. Find out how you can make him really leap out of the page.

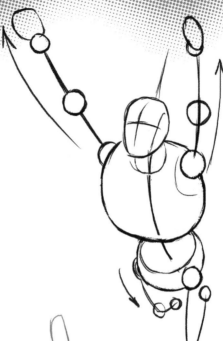

**1** This flying hero is propelling himself upward from a rooftop to take flight. One leg is bent as he pushes up, but the rest of his body is stretching into the sky.

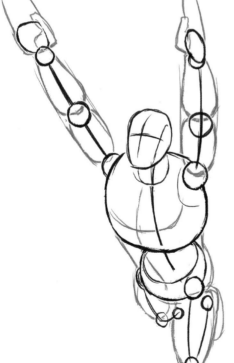

**2** This character has a classic superhero body—muscular with wide shoulders and a large chest, like a bodybuilder. His hands are reaching toward us, so they appear bigger than his head. The whole figure forms a slim triangle.

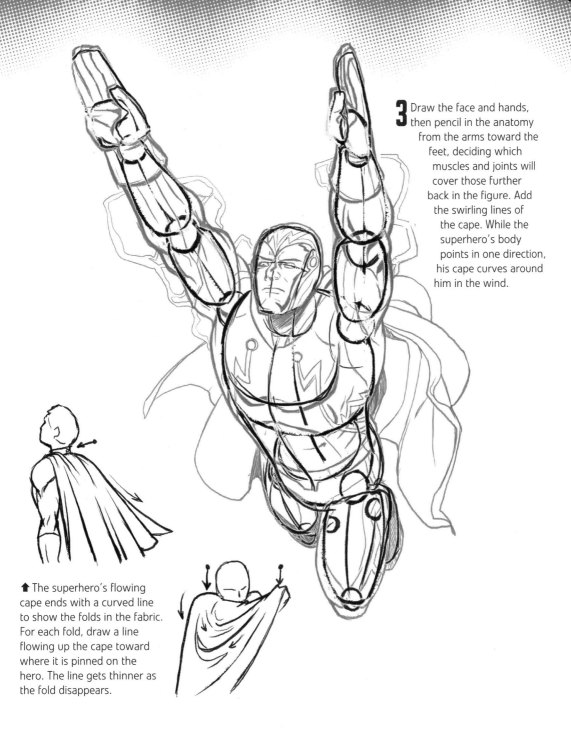

**3** Draw the face and hands, then pencil in the anatomy from the arms toward the feet, deciding which muscles and joints will cover those further back in the figure. Add the swirling lines of the cape. While the superhero's body points in one direction, his cape curves around him in the wind.

⬆ The superhero's flowing cape ends with a curved line to show the folds in the fabric. For each fold, draw a line flowing up the cape toward where it is pinned on the hero. The line gets thinner as the fold disappears.

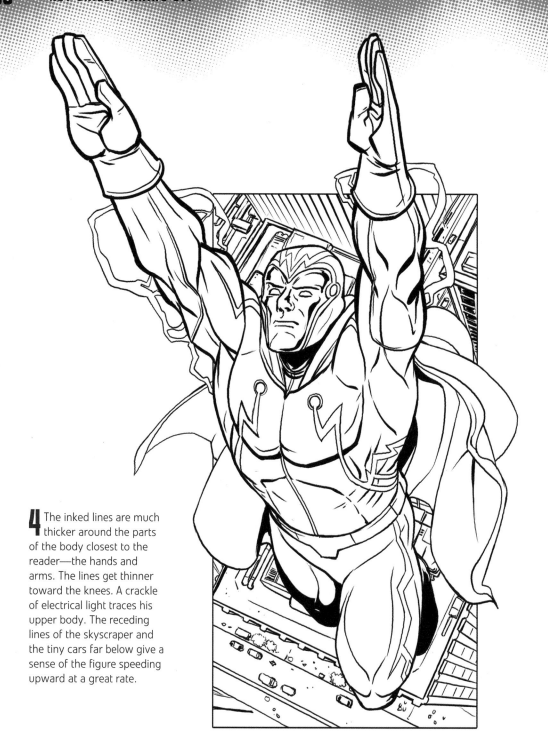

**4** The inked lines are much thicker around the parts of the body closest to the reader—the hands and arms. The lines get thinner toward the knees. A crackle of electrical light traces his upper body. The receding lines of the skyscraper and the tiny cars far below give a sense of the figure speeding upward at a great rate.

# PRACTICE

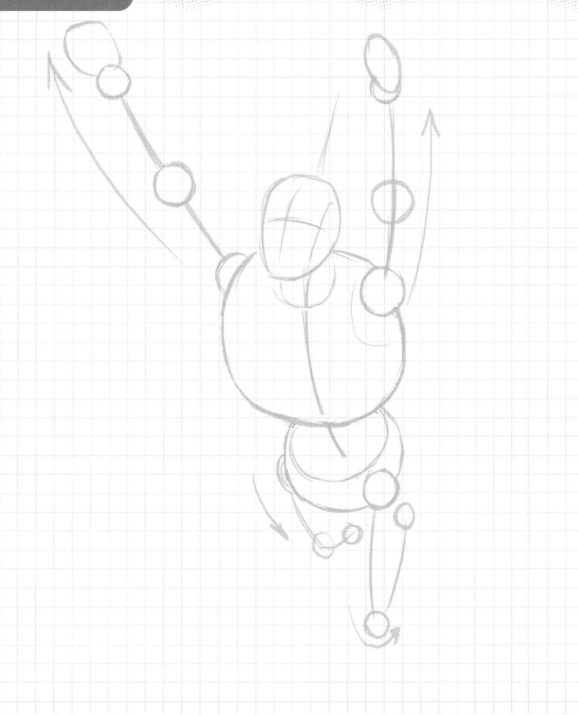

# AN ACTION SCENE

Once you have practiced drawing your characters
individually in various poses, try putting them together in
a scene. Here the two superheroes G-Force and Victory
are in an aerial battle against a supervillain. In a comic book
strip, a larger scene like this is called a splash panel.

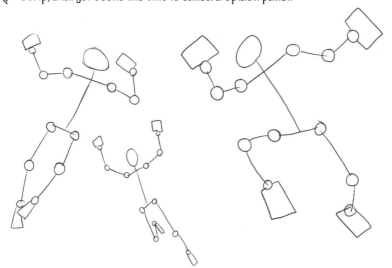

**1** Place each figure
carefully on the page.
The largest character
is the hefty supervillain
on the right. Victory is
smaller than G-Force,
because she is farther
away from the viewer.

**2** The outstretched
arms of each of the
combatants shows they
are balanced and poised,
either on the floating
platform or in midair,
ready to strike. Lightly
sketch in the buildings
behind them, making
sure they look three-
dimensional and to scale.

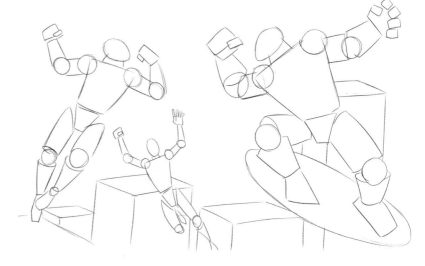

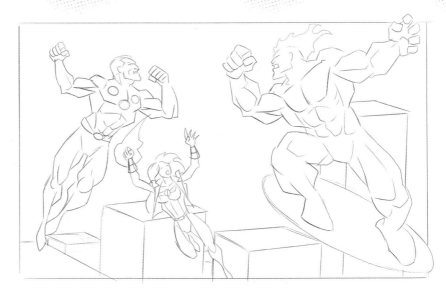

**3** Now flesh out each of your characters. Plan the basic positioning of facial features, and sketch in their muscles and costume elements. Where is each character looking? What are they about to do?

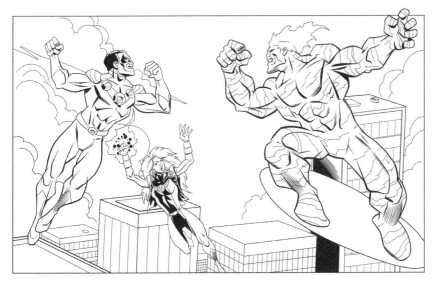

**4** As you ink the image, pay special attention to your characters' faces. Use a ruler to add details to the buildings. Work in some blocks of shading on G-Force's hair, Victory's costume, and the building behind the supervillain.

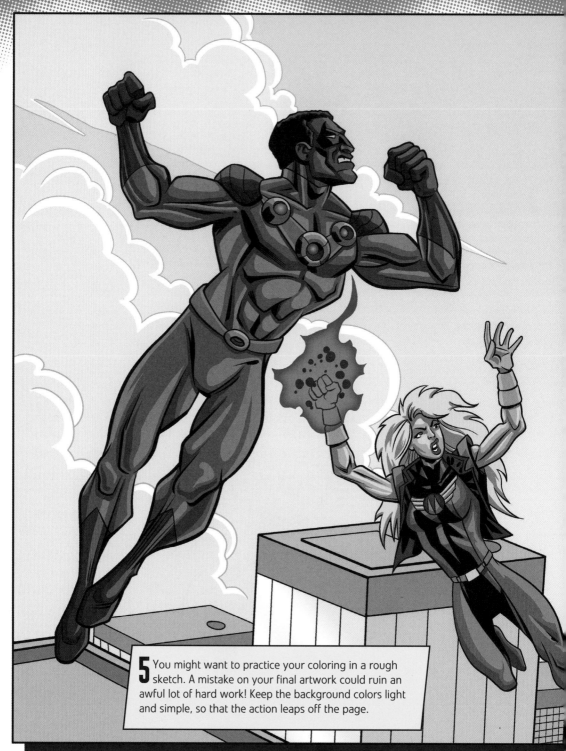

**5** You might want to practice your coloring in a rough sketch. A mistake on your final artwork could ruin an awful lot of hard work! Keep the background colors light and simple, so that the action leaps off the page.

PRACTICE

# SCIENCE FICTION COMICS

Set the photon drive to ultra-luminal speed, Captain: we're about to enter the world of science fiction comics! In this chapter you'll learn some important new comic art skills.

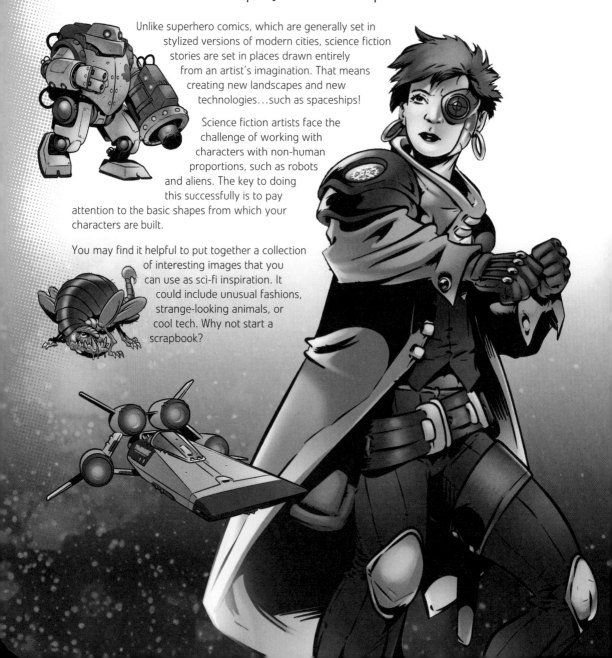

Unlike superhero comics, which are generally set in stylized versions of modern cities, science fiction stories are set in places drawn entirely from an artist's imagination. That means creating new landscapes and new technologies…such as spaceships!

Science fiction artists face the challenge of working with characters with non-human proportions, such as robots and aliens. The key to doing this successfully is to pay attention to the basic shapes from which your characters are built.

You may find it helpful to put together a collection of interesting images that you can use as sci-fi inspiration. It could include unusual fashions, strange-looking animals, or cool tech. Why not start a scrapbook?

# CHARACTER INSPIRATION

Science fiction is an imaginative genre. You will need to be able to draw creatures that look very different from those we might find on earth, as well as consider your human characters' needs in outer space.

## STRANGE ANATOMY

Alien characters give you the freedom to break anatomy rules, though it may help to base your alien forms on human or animal bodies, even mixing them up. While Fzzik walks on two legs like a human, he is somewhat insect-like, with four double-jointed arms. Lilac fur adds another alien touch.

## ENVIRO-SUIT

This human character needs a spacesuit to survive in the cold, airless environment of outer space. Her suit is based on 21st-century design but is leaner due to advances in spacewear since interstellar travel became possible.

## CUTE CRITTERS

If you want a creature to act like an appealing and lovable companion, you will need to follow certain rules. Large heads, big eyes, and rounded body shapes make for cute creatures. Just about everything else is up to you.

# A SPACE PIRATE

Captain Xara Quinn used to work for the intergalactic police, but she became angry with the corruption she saw. Now she's going it alone and knows there's no such thing as good guys and bad guys: it's every woman for herself!

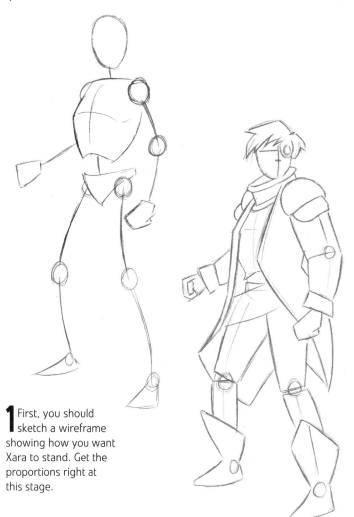

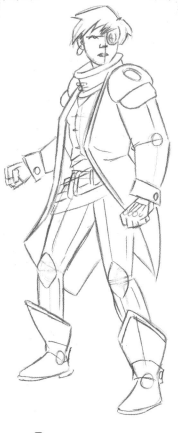

**1** First, you should sketch a wireframe showing how you want Xara to stand. Get the proportions right at this stage.

**2** Flesh out the wireframe with the basic shapes for legs and arms. Add the outline of Xara's military coat and boots. Sketch a cross on her face to get the features in the right place.

**3** In true pirate fashion. Xara has an eyepatch—but hers is a futuristic, cybernetic scanner. Sketch her short, funky hair. Add armored shoulder and knee pads and studded gloves. Her hoop earrings are another nod to old-world pirates.

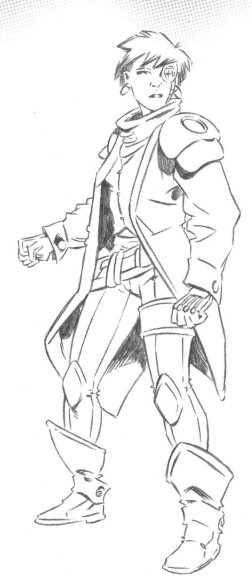

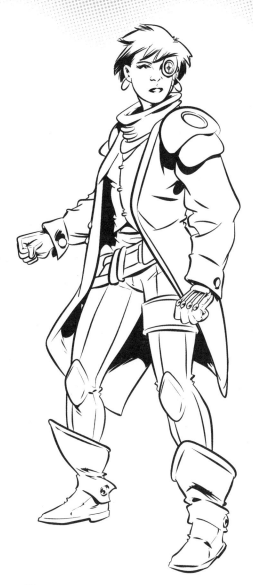

**4** Work up the details of her outfit, such as her utility belt and thigh cuff. Add shadows underneath her coat. A few delicate lines here and there show the folds of her clothes and boots. Finish the features of her face, keeping her tough but feminine.

**5** Now you can begin to go over your final lines with ink. Erase any guidelines that are still visible. Use a fine pen so that you can draw small details, such as her gloves and buttons.

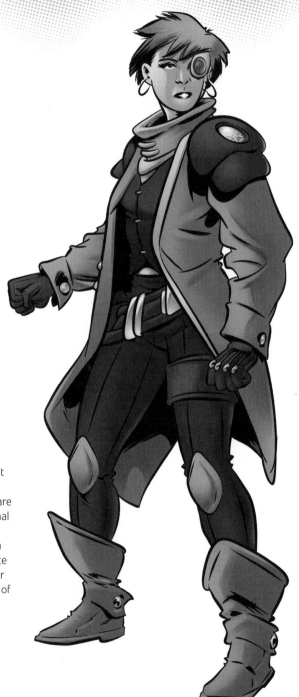

**6** Think carefully about your color scheme. Xara's coat and boots are reminiscent of traditional pirates, but her green spiky hair feels modern or even futuristic. Notice how the shading on her coat uses darker tones of the basic colors.

PRACTICE

# AN ALIEN BIKER

It may look like someone has stolen this alien biker's wheels, but that's no ordinary bike he's riding. It's a hoverbike! Vrilak Skree is the leader of a famous space gang. No one would be foolish enough to steal from him.

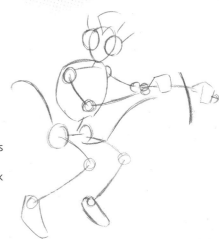

**1** Loosely sketch the circles needed for his head, body, and joints. Give Vrilak elongated arms and legs.

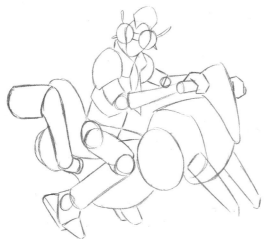

**2** When you're happy with his seated position, add the basic shapes of his bike. Play around with different shapes to see what looks best. Build up the outline of his limbs and clothes.

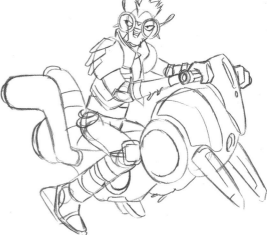

**3** Let your imagination run wild when you fill in the details on his bike and outfit. When creating science fiction vehicles, it's a good idea to look at real, present-day vehicles for inspiration. Use the elements that you think look cool.

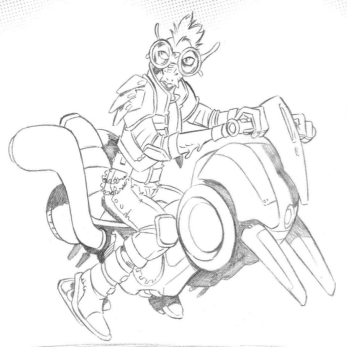

**4** Think about where the light is coming from and how it will cast shadows. Lit from above, the underside of the bike will be in darkness, with shaded areas where Vrilak's body blocks the light, too. Keep adding more textural details to his outfit. He loves all kinds of studs, chains, and metal plates!

**5** Take your time at the inking stage. You don't want to ruin your hard work now that you've come this far. You'll need a steady hand for the curves and circles. Keep the lines on the bike to a minimum, so that Vrilak is still the main focus of attention in the image.

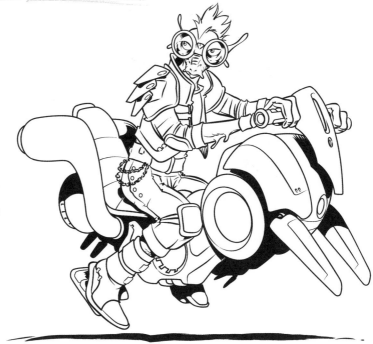

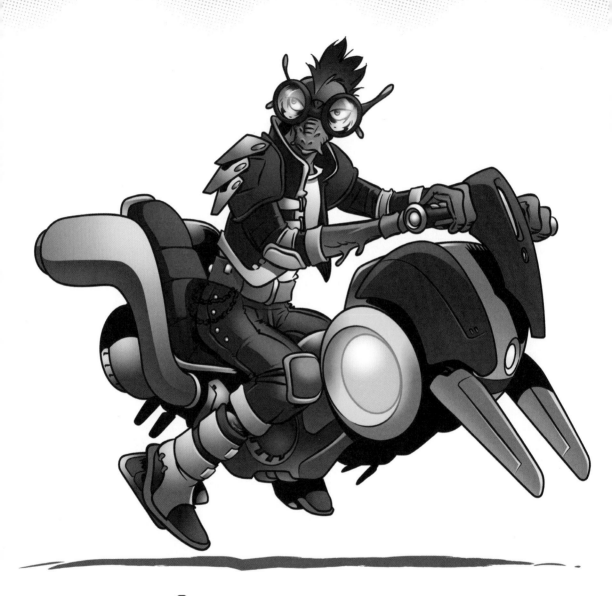

**6** You can have fun choosing strange colors for your alien creatures. Vrilak has green skin like a reptile. The silver and red details of his armor stand out nicely against his black jacket and blue pants. His mohican and his shoulder guards match the bodywork of the bike. What a show-off!

PRACTICE

# KEY SKILL: ROBOTS AND SPACESHIPS

Drawing robots and spaceships can be daunting, but remember that they start with simple shapes. Get the initial shapes right and you will be right on track.

**1** Robots can be any size and shape. This one runs on wheels and is built around a series of 3D shapes. It is a war-robot, designed to be tough and deliver massive firepower.

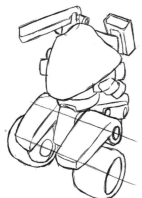

**2** More parts are added, and 3D shapes are given smoother outlines. The chunky tyres are designed for crossing extreme terrain. The machine has a sleek laser cannon mounted on one shoulder.

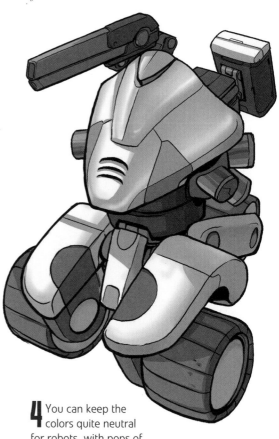

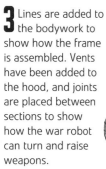

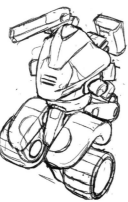

**3** Lines are added to the bodywork to show how the frame is assembled. Vents have been added to the hood, and joints are placed between sections to show how the war robot can turn and raise weapons.

**4** You can keep the colors quite neutral for robots, with pops of color for key mechanisms such as robotic eyes and weapon controls.

Inspiration for transport can come from anywhere, not just existing vehicles. This Vespid fighter ship is based on a household detergent bottle! The cap has been extended to create a nose cone. The pilot sits inside the handle, and jagged fins sprout from the rear, surrounding its nuclear propulsion engine. The ship is armed with extending plasma cannons—one on each side—with two radion torpedoes ready for launch from the nose cone.

This space freighter doesn't have to have an aerodynamic shape. It is designed for long voyages and carrying large cargo. It is built around a collection of 3D shapes—three large spheres for cargo—held together by a frame where the crew live and work.

There is nothing glamorous about this transport vehicle. The body work is made up of thousands of metal plates. The windows and lights look tiny, which tells you how massive it is. It is too big to land on a planet. The crew leave it in orbit and use shuttles to visit other worlds.

# PLANET IN PERIL

Let's plan and create a dramatic action scene set on an alien planet. The alien Absorbots are threatening to sap the life energy of the lush planet Phylla. The Outriders—a rogue band of human and alien space heroes—are fighting to protect this world from annihilation.

**1** Roughly plan the positions of your heroes and robotic villains in the alien scene. The Absorbots are defending their life-draining machine (on the right) from attack. The suited human on the left is leading the attack, along with her three alien accomplices, placed around the scene. Spacing the characters out like this gives the scene depth and interest.

**2** Build up the figures and machinery with 3D shapes. The grid of perspective lines shows the direction of action, moving toward the Absorbots' machine on the right. In Western comic books, the action on the page is usually read from left to right, especially in a big scene like this.

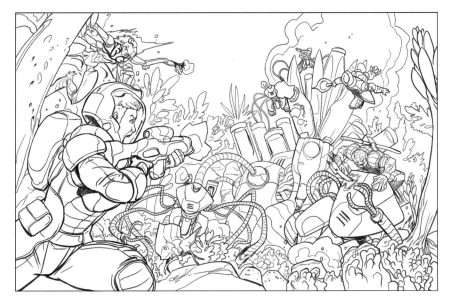

**3** As you work on your detailed pencil drawing, try to make the curves of the plant life contrast with the blocky shapes of the Absorbots. The alien plants resemble a coral reef.

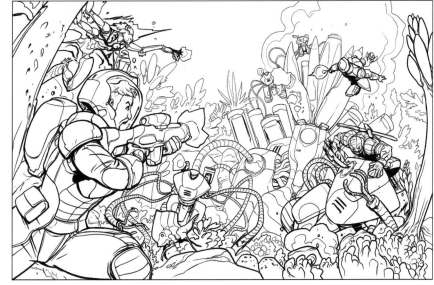

**4** The finished scene is inked. Bolder outlines help the characters stand out from the background. There is a lot going on, but your eye should be led around the scene quite easily.

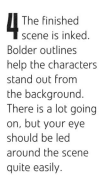

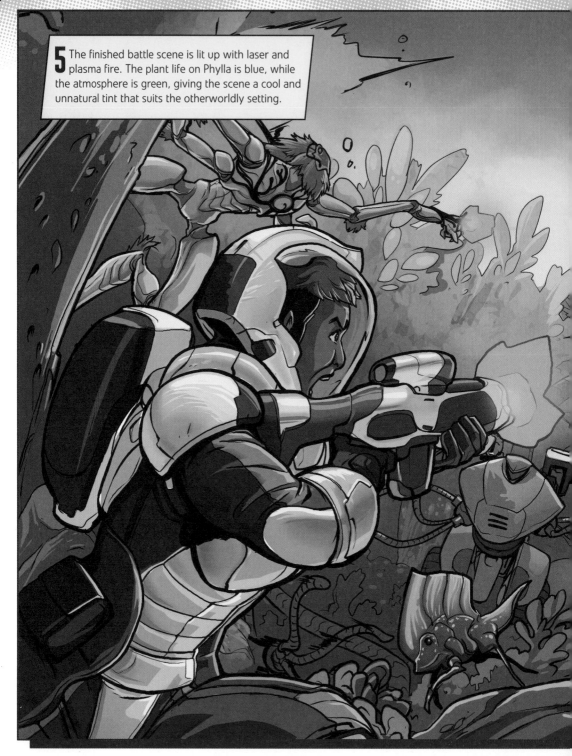

**5** The finished battle scene is lit up with laser and plasma fire. The plant life on Phylla is blue, while the atmosphere is green, giving the scene a cool and unnatural tint that suits the otherworldly setting.

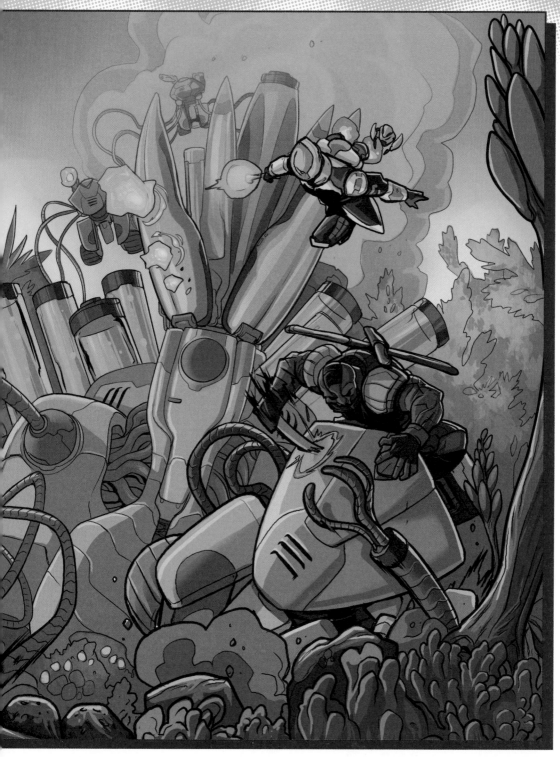

PRACTICE

# FANTASY COMICS

Get ready to swash your buckler and sling some spells!
We're about to venture into the epic world of fantasy comics.

What are the components of a suit of armor?
How does an archer hold a bow? Fantasy comic
illustrations require a little more background
research than artworks for most other types of
comics. That's because they involve drawing
real, non-imaginary objects, but objects that
are not familiar from the present day.

Most of the artworks in this chapter are
based on medieval European history.
However, you may wish to research other
eras of history for your own
story. Why not create a tale of doomed
love and dragon spirits in ancient China?
Or a quest for revenge, set among the
thunderbirds of Native American mythology?

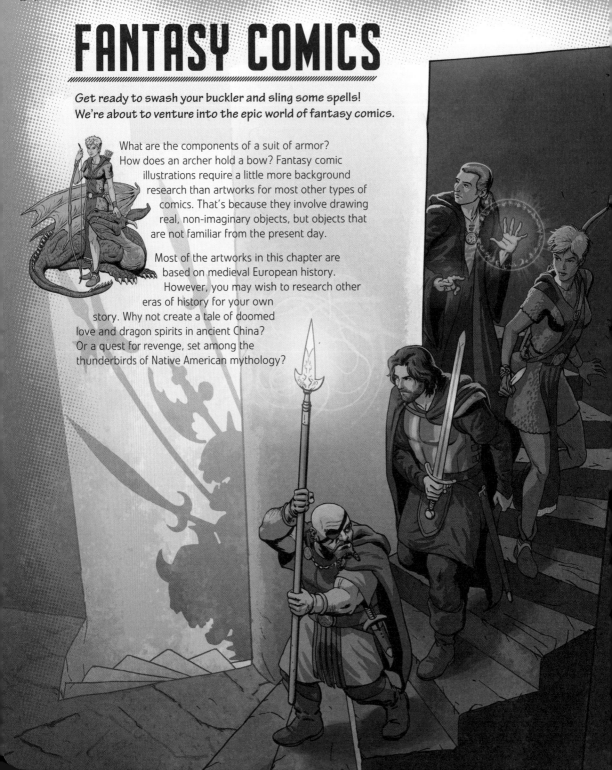

# CHARACTER INSPIRATION

Warriors, elves, magicians, trolls, ogres, dwarfs—fantasy characters come in all shapes and sizes. Consider where your mystical characters will derive their power from, and if they have any vulnerabilities their opponents can exploit.

## WIZARDS AND WITCHES

Magical heroes rarely wear the tight outfits popular with muscular superheroes. Instead they have flowing robes and capes. Modern mage Charm can summon supernatural creatures to her aid through the use of mystical artifacts.

## VARIED BUILDS

Many of your characters will have a non-human form. You can play around with proportions, changing the length of limbs, size of the head and so on, for great effects.

## WEAPONS AND ARMOR

Your fantasy characters will need to be well armed! From swords to cudgels, you can take inspiration from weapons throughout history. You had better think about some protective gear, too!

# AN ELF PRINCE

Though not as physically strong and imposing as a warrior or an orc, this regal and revered fighter is just as dangerous. He relies on his deadly accurate aim, naturally heightened senses, and athletic skills to see him through a battle.

**1** Start by drawing your frame, adding the bow he is pulling back, ready to fire.

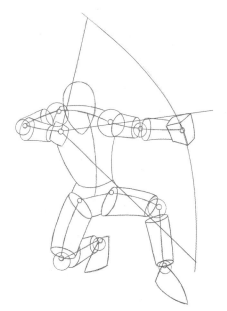

**2** Build on your frame using basic shapes. His left arm, that's stretched out in front, will appear larger as it's further forward.

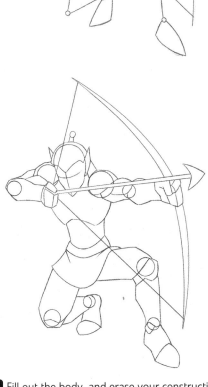

**3** Fill out the body, and erase your construction shapes. Draw his elf ears, weapon, and clothing as your prepare your clean pencil drawing.

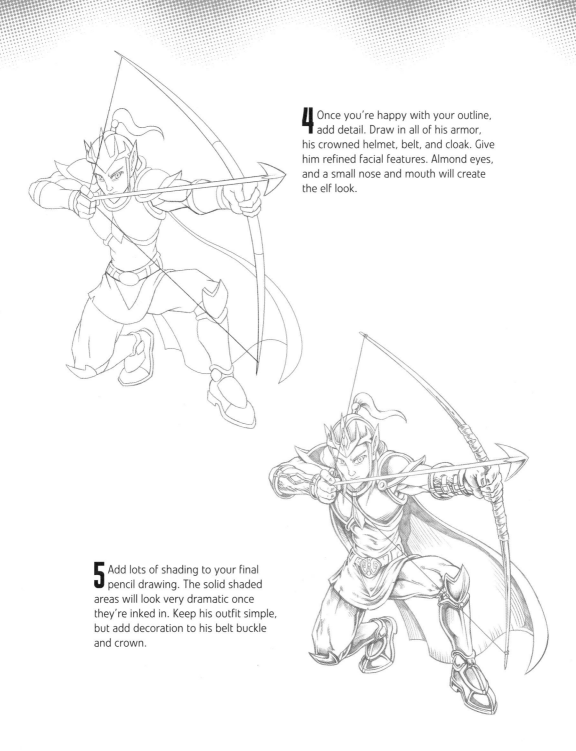

**4** Once you're happy with your outline, add detail. Draw in all of his armor, his crowned helmet, belt, and cloak. Give him refined facial features. Almond eyes, and a small nose and mouth will create the elf look.

**5** Add lots of shading to your final pencil drawing. The solid shaded areas will look very dramatic once they're inked in. Keep his outfit simple, but add decoration to his belt buckle and crown.

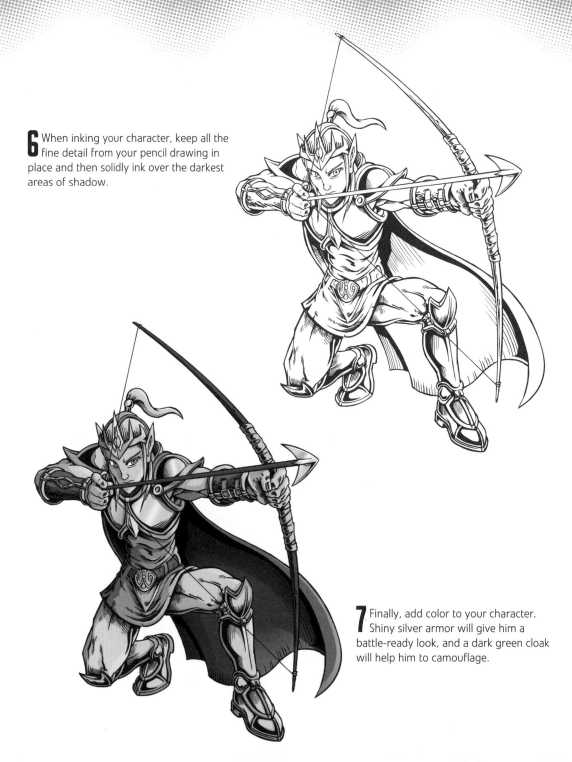

**6** When inking your character, keep all the fine detail from your pencil drawing in place and then solidly ink over the darkest areas of shadow.

**7** Finally, add color to your character. Shiny silver armor will give him a battle-ready look, and a dark green cloak will help him to camouflage.

# PRACTICE

# A DWARF WARRIOR

From the stone kingdom of the western mountains comes this mighty warrior. Armed with incredible strength and determination, this dwarf likes nothing more than seeing evil fall beneath the power of his ancient hammer.

**1** Start by drawing the basic stick figure. The dwarf warrior's body is short and stocky, and he is ready for battle.

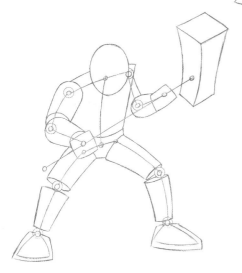

**2** Build on your frame by adding basic shapes. Use thick, short cylinders to form his legs and arms, then add a rectangular block as a base for his hammer.

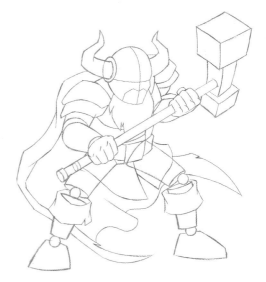

**3** Keep building on your figure, removing your stick figure lines as it takes shape. The dome of his head forms the basis for his helmet. Add the horns on either side. Mark in his beard, clothing, boots, and armor. Flesh out his hands and arms, and use blocks to divide his hammer's head into sections.

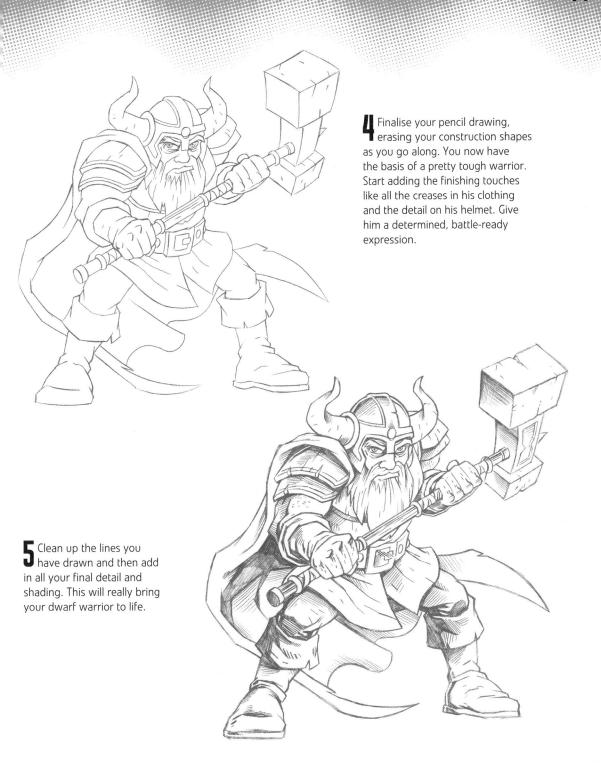

**4** Finalise your pencil drawing, erasing your construction shapes as you go along. You now have the basis of a pretty tough warrior. Start adding the finishing touches like all the creases in his clothing and the detail on his helmet. Give him a determined, battle-ready expression.

**5** Clean up the lines you have drawn and then add in all your final detail and shading. This will really bring your dwarf warrior to life.

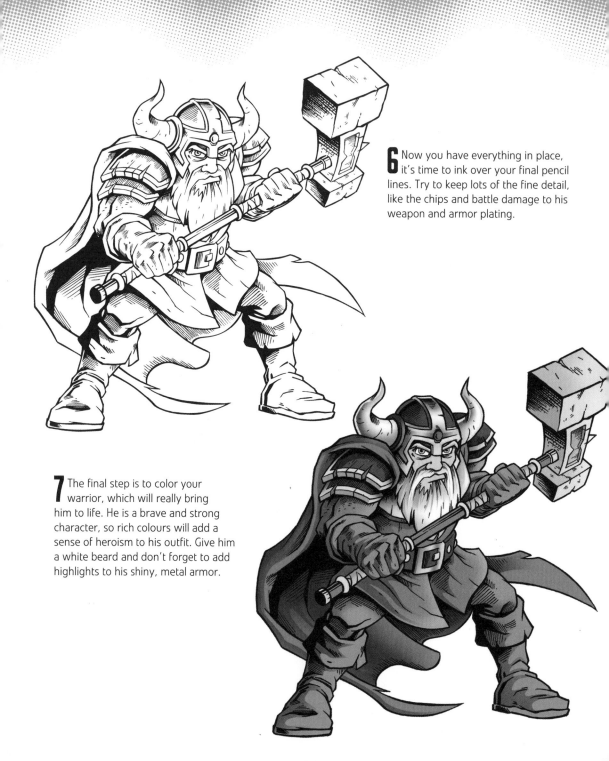

**6** Now you have everything in place, it's time to ink over your final pencil lines. Try to keep lots of the fine detail, like the chips and battle damage to his weapon and armor plating.

**7** The final step is to color your warrior, which will really bring him to life. He is a brave and strong character, so rich colours will add a sense of heroism to his outfit. Give him a white beard and don't forget to add highlights to his shiny, metal armor.

# PRACTICE

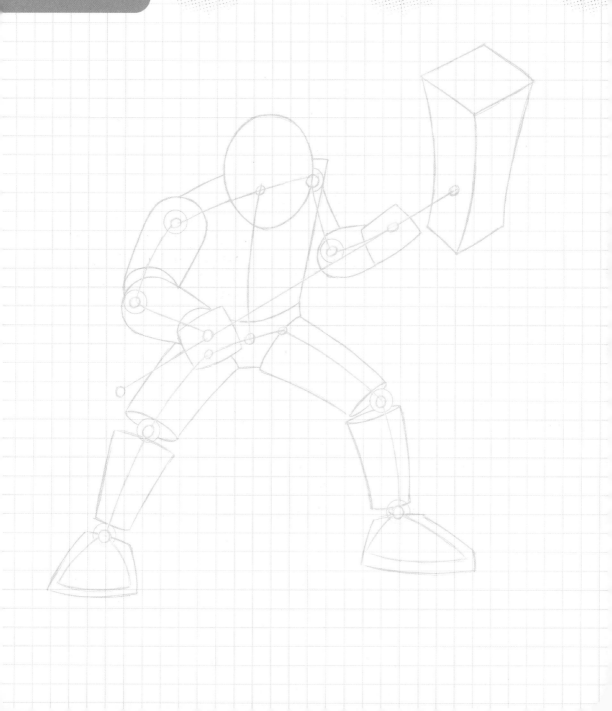

# KEY SKILL: MYSTICAL RELICS

Fantasy worlds are imbued with magic. Magical objects often change hands and can lead to a story with good and evil magicians fighting for ownership. Practice drawing these examples and invent some of your own.

## SPELL

➡ What does a spell look like? Here, Charm is twisting her fingers into special spell positions. Circles of magic light surround her hand, and streams of mystic force radiate outward, ready to be directed at their target.

## AMULET

⬅ This amulet holds the Orb of Voltain, a stone of ancient, possibly extra-dimensional origin. The sparkles in the gem suggest a whole galaxy is contained within it. Worn around a magician's neck, it offers protection against evil incantations.

## STAFF

➡ Cut from the same willow as the cane of the legendary mage Merlyn, this staff of power is inscribed with potent spells. It can lead its bearer away from danger and discharge the lightning of wrath upon enemies. Look at old languages, such as Viking runes, then design your own language for writing spells.

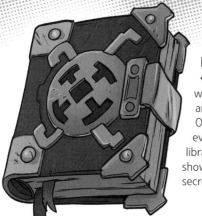

### BOOK

← Containing the wisdom of the witch Magluthra, this book of spells and remedies was kept safe by the Order of Z'Tor for centuries until the evil Lord Tralon stole it from their library. The worn bindings and leather show its age. A strong lock suggests its secrets need protecting.

### CRYSTAL

➡ Stolen from the Cave of the Fair Elves, this crystal contains a source of fairy magic. Combined with the right words, it allows its bearer to use many powerful enchantments.

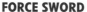

### FORCE SWORD

➡ The Nornsword, wrought from rare norn metal, can cut and wound supernatural beings immune to other earthly weapons. Anointed with a spell of revelation by the wizard Amouthrir, it glows when faced with untruths. Adding a history, unique source or engraving to a familiar weapon can turn it into an object of magic.

### SHIELD

← The Shield of Styrig is said to be the same one that the wizard-slayer Styrig used to defeat the Coven of Kruel in the world before time. It can deflect any spell, reflecting it back to the one who cast it. Your fantasy stories don't have to be set in the present day. Why not invent a magical past that was never described in the history books?

# A WIZARD'S BATTLE

In this dramatic scene, a quick-witted young wizard, Jaryth, is shown in battle against the evil Queen of Ashes. Take your time to get the perspective right as it is key to making the castle backdrop look believable—even if the rest of the scene is fantasy!

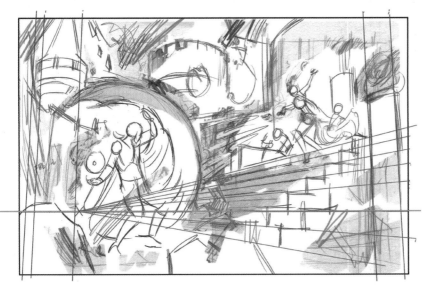

**1** Decide on your vanishing point. Use the lines of the staircase to set up your perspective. Sketch the basic frames for Jaryth and the Queen, her minions and the background.

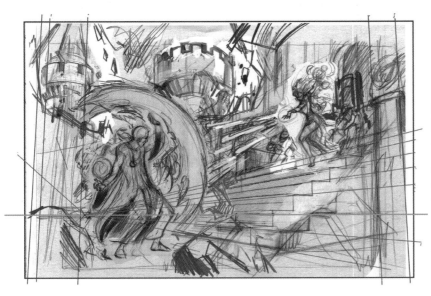

**2** Gradually build up the layers of detail in the foreground and background. Now concentrate on your characters. Jaryth is closer to the viewer, so he appears larger than the Queen of Ashes. Add in the details of clothing and the magical "special effects" for the fight.

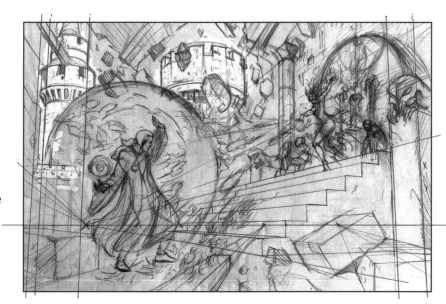

**3** When you're satisfied with the way the scene is shaping up, you can think more about textures and plan the way that lighting will cast shadows. Add detail to the fiery shield and the pieces of masonry falling from the roof.

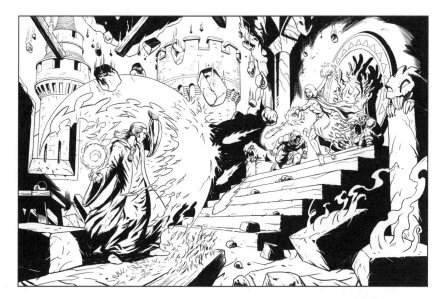

**4** The inked artwork is dramatic, with strong contrasts of light and dark (this is called "chiaroscuro"). There are no unnecessary lines or shading, but the viewer can spot details like the statues and horned figures as they take a closer look.

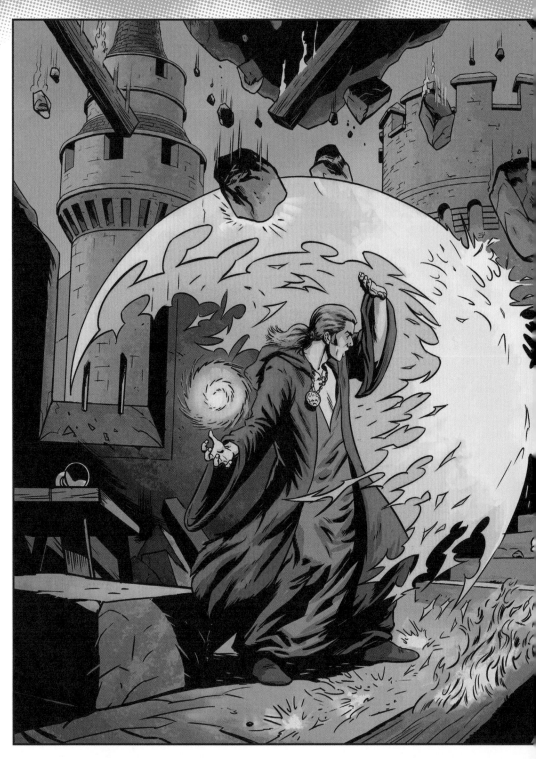

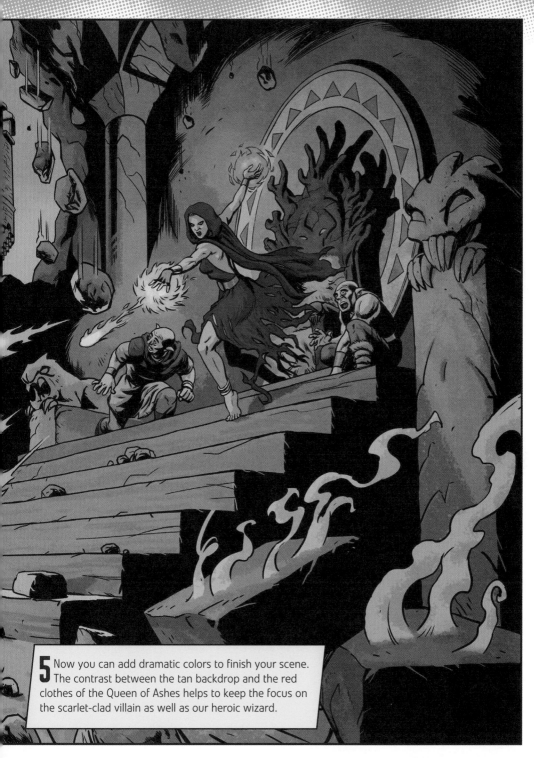

**5** Now you can add dramatic colors to finish your scene. The contrast between the tan backdrop and the red clothes of the Queen of Ashes helps to keep the focus on the scarlet-clad villain as well as our heroic wizard.

## PRACTICE

# MANGA COMICS

**It's time to swap your broadsword for a *katana*! This chapter will set you on the path to becoming a black belt in the Japanese art of manga.**

Manga comics can be about the same themes we've already covered—superheroes, science fiction, or fantasy. But they also have something that sets them apart as being uniquely Japanese! Manga uses many different techniques to European and American comics.

In this chapter you will find out how to draw manga faces and bodies, which use different proportions. We will also look at how manga characters display emotion.

Manga comics use super-cool, stylized ways of showing movement. Once you have studied the manga approach, you may find that you can adapt elements of it when drawing in a non-Japanese style.

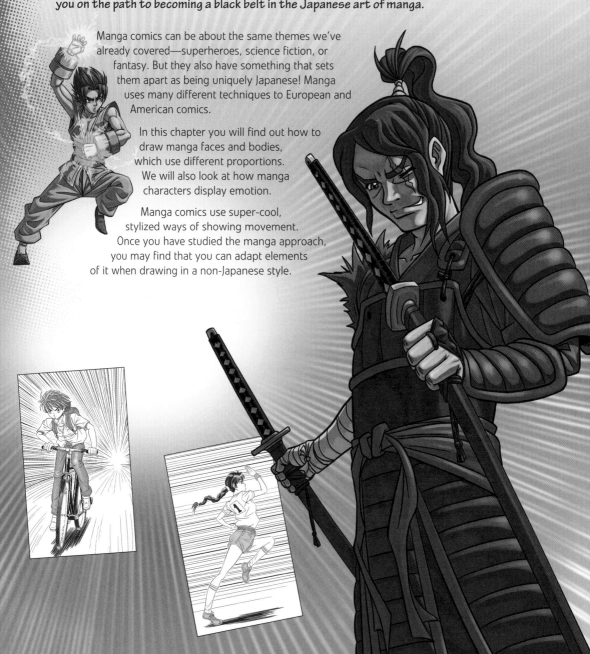

# CHARACTER INSPIRATION

Manga characters are as varied as your imagination makes them; from super-cute and super-cool to sinister and monstrous. Most manga art fans love a fight scene, and many characters are martial arts masters.

## COOL KID

A character's clothing can say a lot about their personality. This skateboarder sports a bandana and three-quarter length combat trousers. He's keeping it cool, but ready for action!

## MARTIAL ARTS

These two characters are formidable fighters. The boy is wielding energy nunchakus, while the girl's speed and power are shown with fiery special effects.

# MANGA PROPORTIONS

It's important to think about proportions when drawing your manga characters. If your figures' arms or legs are the wrong length, those basic errors will stick out like a sore thumb!

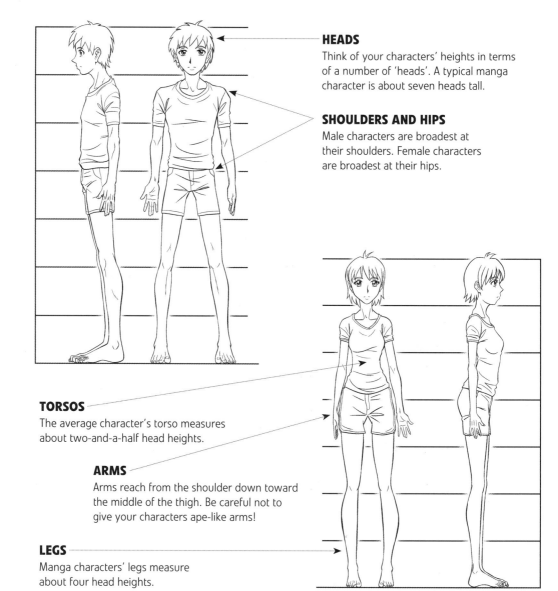

## HEADS
Think of your characters' heights in terms of a number of 'heads'. A typical manga character is about seven heads tall.

## SHOULDERS AND HIPS
Male characters are broadest at their shoulders. Female characters are broadest at their hips.

## TORSOS
The average character's torso measures about two-and-a-half head heights.

## ARMS
Arms reach from the shoulder down toward the middle of the thigh. Be careful not to give your characters ape-like arms!

## LEGS
Manga characters' legs measure about four head heights.

# MANGA HEADS

By remembering a few simple rules, you can make sure that your manga faces look appealing. This will also help with keeping faces consistent from one panel to the next.

### FRONT VIEW

In manga, as in real life, eyes are positioned about halfway down the head. But manga eyes are much larger than real ones!

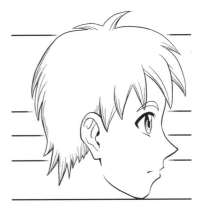

### SIDE VIEW

Manga noses are almost invisible when shown head-on. From the side, they are cute and pointed, extending for roughly one eye-height.

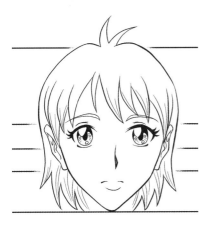

### BOYS AND GIRLS

Male and female characters both have slim faces. Girls' faces tend to be narrower, with a more pointed chin. They also have longer eyelashes.

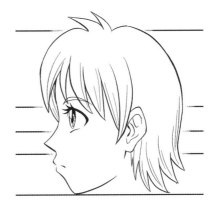

### EYEBROWS AND EARS

In manga, both male and female eyebrows are narrow and gently arched. Ears extend from the top of the eyes to the bottom of the nose.

# A MONSTER TRAINER

It's time to tackle your first manga character! Meet our magical trainer, Tokiko, and her tame monster. The creature is a *kitsune*, a mythological fox with supernatural abilities. *Kitsunes* have many tails, which show their age and power.

**1** As usual, start by sketching a wireframe. This allows you to get the stance and proportions correct.

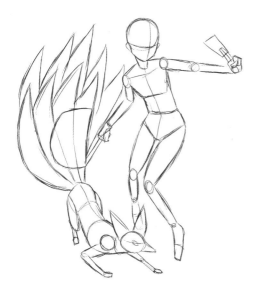

**2** Roughly sketch in all the elements of the image, from the *kitsune's* nine tails to the trainer's talismans. She is carrying a magical wand with streamers, called an *ounusa*.

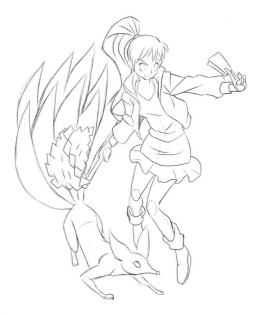

**3** When the proportions are correct, flesh out the figure with clothes and features. Add a high ponytail for dramatic effect and chunky boots to contrast with her frilled skirt. This girl means business!

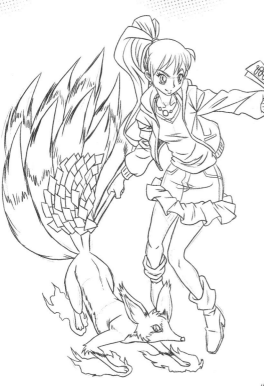

**4** Draw the final details of your image, including the flames at the *kitsune*'s feet. Pencil in folds on the clothes to give the picture movement and texture. Add an inscription on the trainer's *ofuda*—the cards held in her left hand.

**5** Trace over the pencil lines of your image with ink. Then use an eraser to clean everything up. A well-inked image should look sharp and crisp. Now you can see the amount of work that goes into every panel of a manga story!

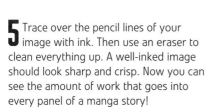

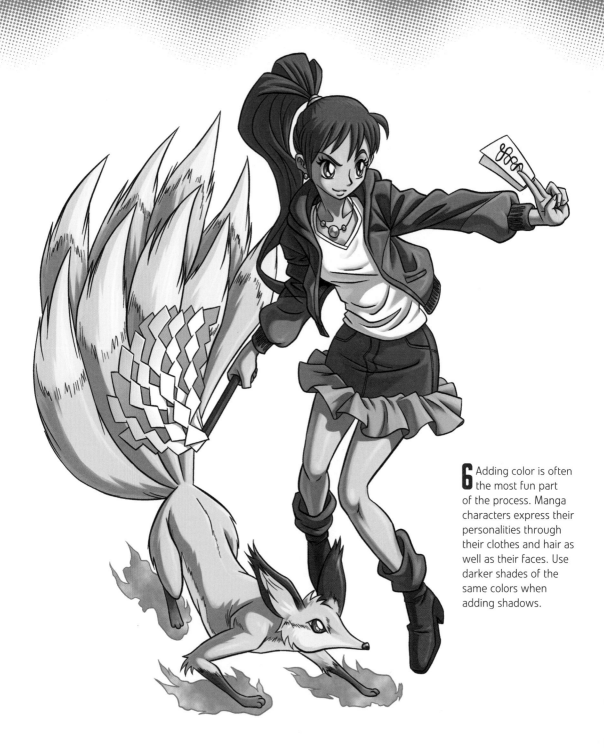

**6** Adding color is often the most fun part of the process. Manga characters express their personalities through their clothes and hair as well as their faces. Use darker shades of the same colors when adding shadows.

PRACTICE

# THE DARK RONIN

Take a step into Japanese history with this troubled warrior. A ronin is a masterless samurai, and our character's stance shows he is a master of martial arts and combat. All samurai carry two swords and sometimes other weapons, too.

**1** Lightly sketch the wireframe, with a guarded stance and two lines for the *katanas*— long, curved Japanese swords.

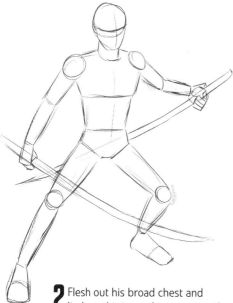

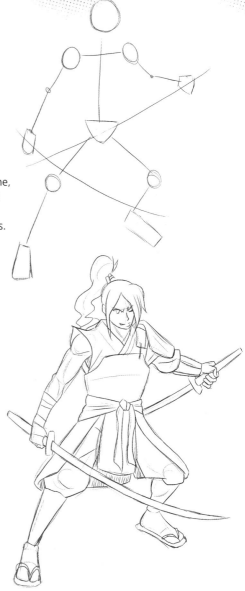

**2** Flesh out his broad chest and limbs—this is no skinny samurai! Make sure his hips are narrower than his shoulders. Pay close attention to the position of his legs and feet.

**3** Add to his roguish qualities with long, loose bangs and a wayward ponytail. His samurai uniform covers his chest and thighs, with a sash belt tied at the waist. Both arms should be protected, but it looks like this isn't his first fight…

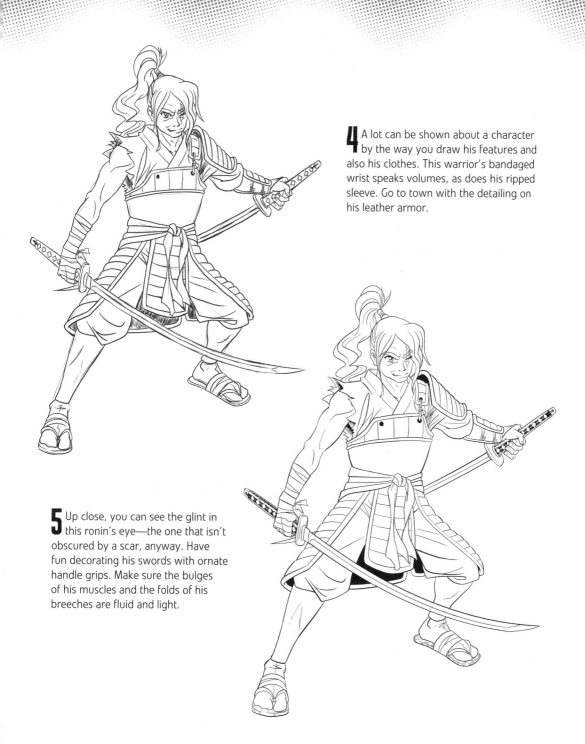

**4** A lot can be shown about a character by the way you draw his features and also his clothes. This warrior's bandaged wrist speaks volumes, as does his ripped sleeve. Go to town with the detailing on his leather armor.

**5** Up close, you can see the glint in this ronin's eye—the one that isn't obscured by a scar, anyway. Have fun decorating his swords with ornate handle grips. Make sure the bulges of his muscles and the folds of his breeches are fluid and light.

**6** When adding color to the warrior, remember that he is a dark soul with a rebellious streak. The clothing beneath his armor should be drab and plain, but he wears his samurai colors with pride. Keep the colors light on the sharp edges of his swords.

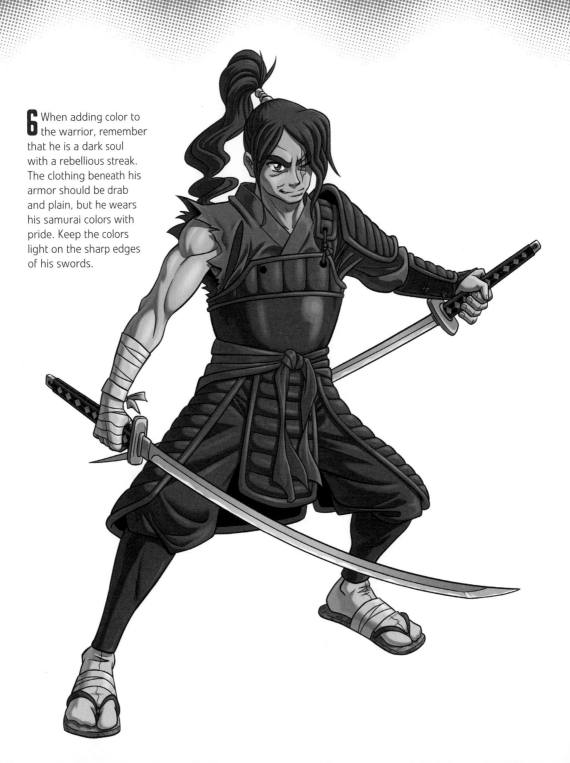

# PRACTICE

# KEY SKILL: SHOWING EMOTIONS

Manga has its own ways of showing what people are feeling. Note that the emotions are conveyed by both the characters' expressions and by the backgrounds.

## NERVOUS

His mouth is smiling, but his eyes look worried. A single bead of sweat tells you this guy is flustered or jumpy.

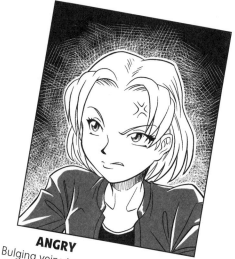

## ANGRY

Bulging veins in the forehead, often drawn as cross-shaped, are a common way of showing anger.

## LOVESTRUCK

Flushed cheeks? Wide eyes gazing into the distance? Flowery background? This character is in L.O.V.E.!

## CHIBI

In manga, characters' emotions are sometimes shown in an exaggerated way by drawing them as chibis for one or more panels, like this lovestruck chibi. Chibis are tiny and childlike, with a head that's almost as long as their body. They usually have no nose!

# SPECIAL EFFECTS

Patterned manga backgrounds do three things: they grab the reader's attention, they show characters' reactions without words, and they make for an interesting break from standard background scenery.

### SURPRISE!
What's happening here? The startling background grabs your attention and makes you want to know more. It's something amazing, judging by the lightning flashes!

### FOCUS LINES
An explosion of lines drawn outward from a focal point makes you instantly aware of what's important in a scene. This can add to the feeling of drama and excitement.

# A DOJO SCENE

You've practiced drawing characters with varied expressions and movements, and adding dramatic effects. Now it's time to put all those skills together to create an action-packed scene in which several characters interact with each other.

**1** Take some time to sketch the position of each character. They should feel like they are interacting in a dramatic way. Where are they each looking? What are they about to do?

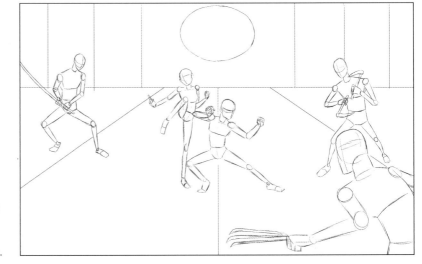

**2** When you are happy with how the characters fill the frame, sketch in the basic lines of the background. Flesh out each figure, making sure they are all in proportion to each other.

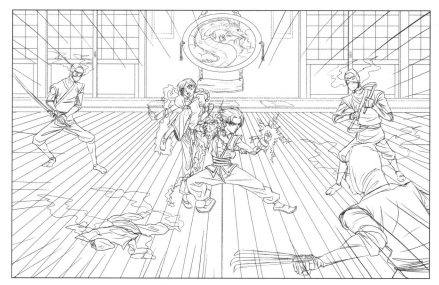

**3** Slowly build up the details of the characters and scenery. Don't ruin your hard work by rushing! Ask yourself: do any areas of the image need more interest? We added some empty robes at the bottom left, to suggest that the ninjas can turn to smoke.

**4** As you ink the image, make sure that it's clear what's happening. Who are the good guys and who are the bad guys? Your scene is telling a story, so it's up to you to show what's taking place. Never lose sight of the big picture!

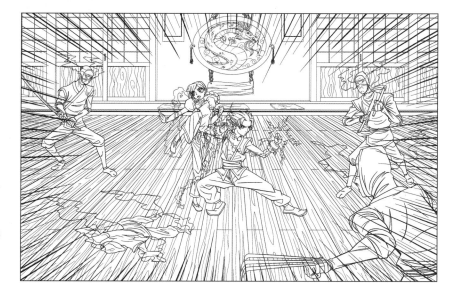

## FEARLESS FACES

Remember what you
have learned about
manga features. Give your
heroes big eyes and expressions of brave
determination to contrast them with the
masked baddies.

## GOING FOR GOLD

Bring the decoration to life
with white-gold highlights and
brown-gold shading.

## GLOWING EYES

Leave the middle of
the ninjas' eyes bright
white, but color the area
around them red.

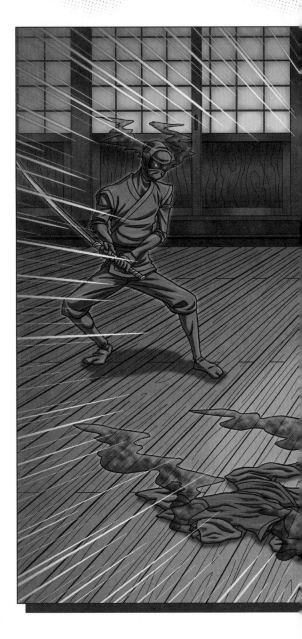

**5** Finally, use your coloring to highlight the main characters and make the villains look sinister. Use bold shades in the center and play with the special effects, adding flames, sparks, and force fields.

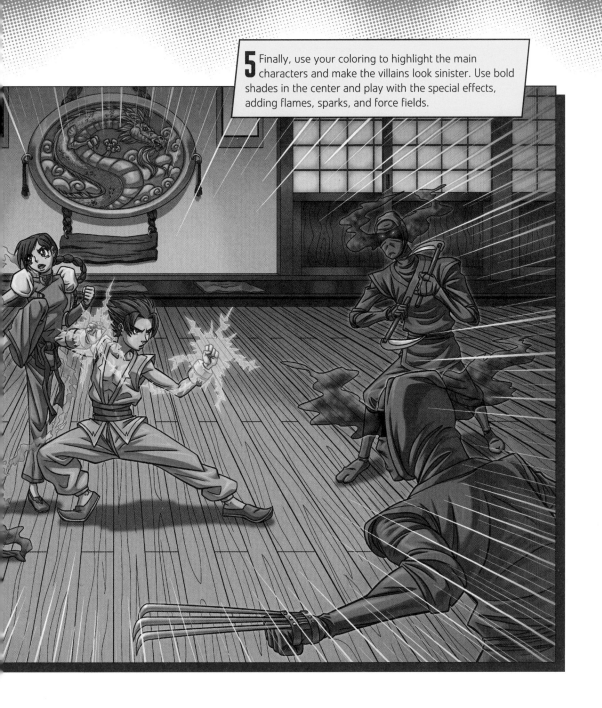

# PRACTICE

# HORROR COMICS

Draw near, weary traveler, for a spine-chilling chapter on horror comics! Do you feel brave enough to tackle some advanced skills in comic storytelling?

We've previously covered various different aspects of drawing backgrounds and scenes. But what is a scene without an atmosphere? In this chapter, you'll discover how to use inking to create mysterious and sinister moods.

The final exercise in this chapter describes how to put together a page with multiple panels. Follow the steps to create a masterpiece of horror storytelling, complete with spooky scenario, dramatic lighting, and a ghastly cast of characters!

# CHARACTER INSPIRATION

The undead, especially vampires and zombies, are a popular choice for horror comic characters. Don't forget the hapless folk who are up against these monsters—showing their reactions is key to creating a spooky atmosphere.

### CLOWN

Clowns, puppets, and mannequins are often used to great dramatic effect in tales of suspense and horror. Heavy make-up and oversized, colorful costumes mask the true emotions and intentions of the performer, which can be unnerving.

The brightly-painted, jolly face of a clown can suddenly take on a sinister appearance when it masks the face of a fiend.

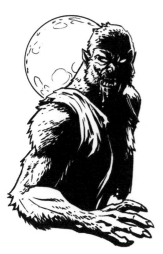

### HORROR HERO

If this dude is scared, he's not showing it! With his feet apart and his hands curled into fists, he's ready to take on any monsters. The determined look on his face says he's a hero.

### WOLF MAN

The moon lights this wolf man from behind, leaving most of him in shadow. His fur is shaded with dashes, which follow the shape of his muscles. Highlights reveal his torn shirt, bright eyes, and blood dripping from his fangs.

### CYBER-ZOMBIE

Kept barely alive by transplants and tech, this cyber-zombie is looking for new organ donors. A few inky patches of darkness show where he needs some medical attention.

# A SWAMP ZOMBIE

This creepy creature has been lying in wait beneath the foul, stagnant waters of an ancient swamp. Now it has finally emerged, and it looks like it's hungry for human flesh! Can you capture its frightening pose and expression?

**1** Use a wireframe to plan how you want your creature to stand and how long its limbs will be. It's tall and skinny.

**2** Develop the hands and feet, with fingers and toes. Use curved lines to outline the thin legs and arms. Connect the hips and chest with a narrow waist, and sketch in facial features.

**3** Add more details. Work up the hollow face with its gaping mouth. Add holes for the eyes and nose. Begin to sketch the loose rags hanging from its body. Use scratchy lines to create ragged edges.

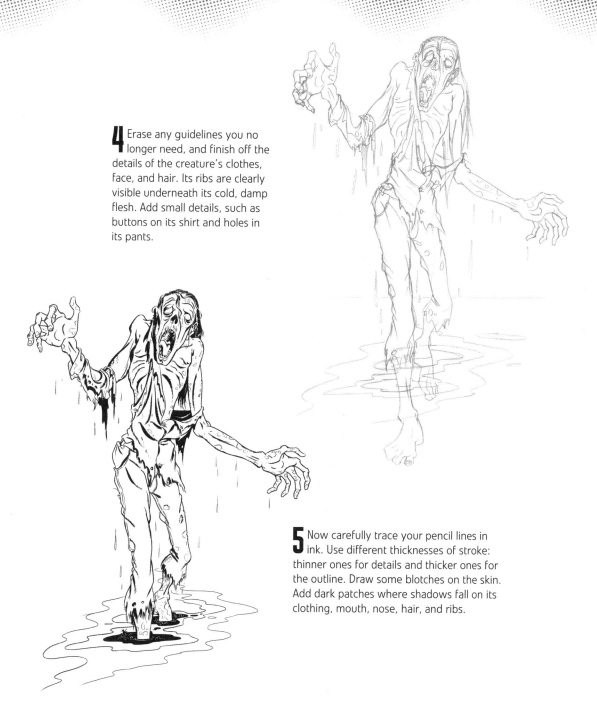

**4** Erase any guidelines you no longer need, and finish off the details of the creature's clothes, face, and hair. Its ribs are clearly visible underneath its cold, damp flesh. Add small details, such as buttons on its shirt and holes in its pants.

**5** Now carefully trace your pencil lines in ink. Use different thicknesses of stroke: thinner ones for details and thicker ones for the outline. Draw some blotches on the skin. Add dark patches where shadows fall on its clothing, mouth, nose, hair, and ribs.

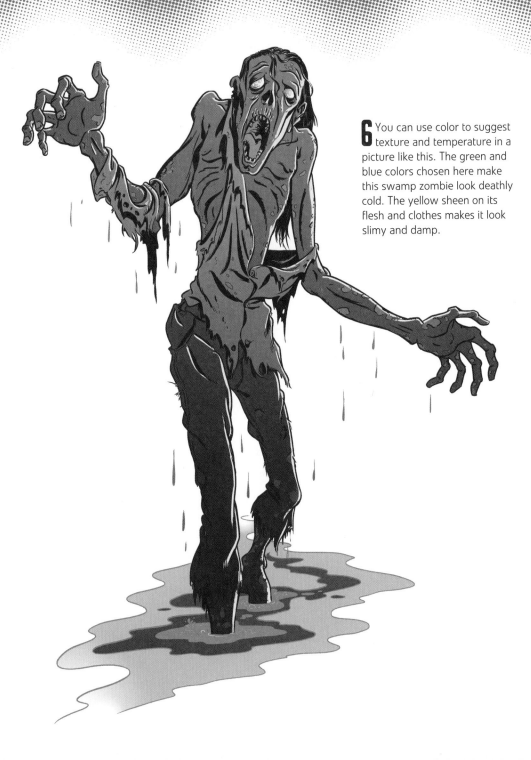

**6** You can use color to suggest texture and temperature in a picture like this. The green and blue colors chosen here make this swamp zombie look deathly cold. The yellow sheen on its flesh and clothes makes it look slimy and damp.

# PRACTICE

# A HAUNTED SCARECROW

This pumpkin-headed scarecrow has been brought to life by a spirit of vengeance from beyond the grave. Beware of its clawlike hands and sharp-pronged pitchfork! What kind of spooky stories will it inspire you to illustrate?

**1** Body language plays an important role in making a creature look sinister. Is this scarecrow warning us away from something?

**3** This picture uses foreshortening to show the creature reaching toward us. The leading hand is much larger than the trailing one, because it is closer to the viewer. Sketch the features on its gruesome face and add detail to its clothing.

**2** Bulk out its frame, giving definition to its skinny arms and legs. Take time to sketch each joint and knuckle for its outstretched, clawlike hand.

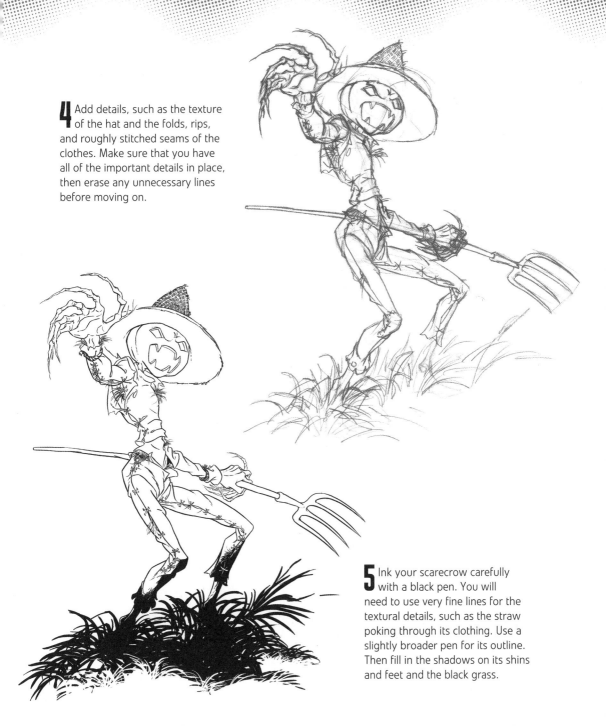

**4** Add details, such as the texture of the hat and the folds, rips, and roughly stitched seams of the clothes. Make sure that you have all of the important details in place, then erase any unnecessary lines before moving on.

**5** Ink your scarecrow carefully with a black pen. You will need to use very fine lines for the textural details, such as the straw poking through its clothing. Use a slightly broader pen for its outline. Then fill in the shadows on its shins and feet and the black grass.

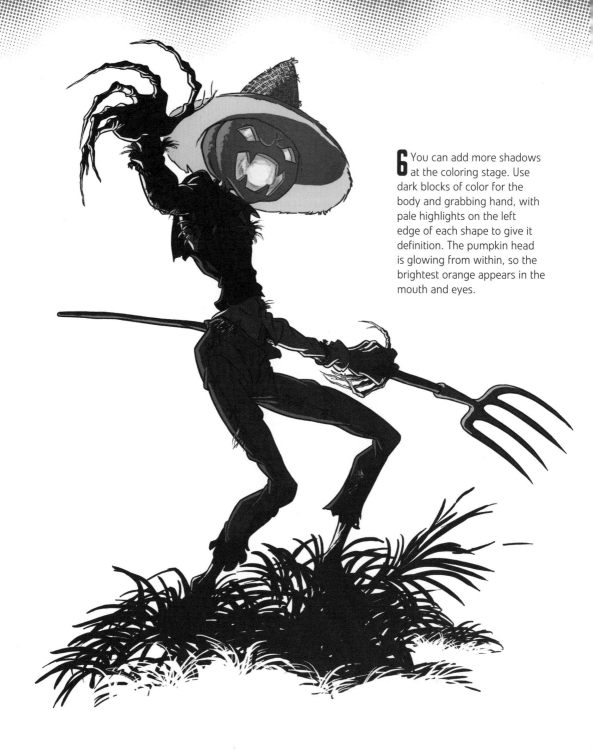

**6** You can add more shadows at the coloring stage. Use dark blocks of color for the body and grabbing hand, with pale highlights on the left edge of each shape to give it definition. The pumpkin head is glowing from within, so the brightest orange appears in the mouth and eyes.

**PRACTICE**

# KEY SKILL: SHADOWS AND ATMOSPHERE

A scene can be completely transformed by the effective use of shadows. A setting that would appear ordinary or even welcoming in good lighting can suddenly become mysterious and sinister.

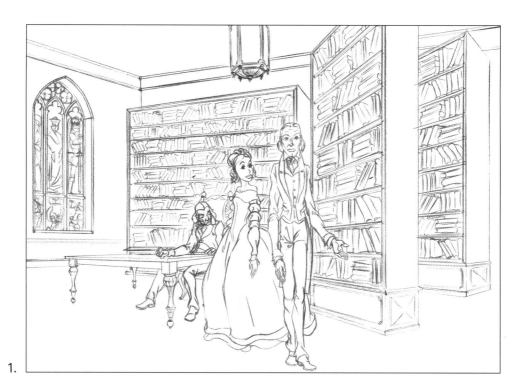

1.

### 1. A SCENE WITHOUT SHADOWS

This library scene could be any ordinary library, although the costumes give a visual clue that it is a historical setting. The light source is unclear: is light streaming through the stained-glass window or coming from the ceiling lamp?

### 2. A SCENE WITH SHADOWS

The artist has added some shadows to this inked version of the image. It feels much more atmospheric, though it is not necessarily a horror scene. The shadows are cast by the books, people, and furniture as the light shines in through the large window on the left.

### 3. A SCENE WITH HEAVY SHADOWS

Now it's clearer that our scene is spine-chilling and spooky! Much of the room is inked out in shadow, allowing us to focus on the characters in the foreground. The chiaroscuro (contrast between light and dark) is very evident here.

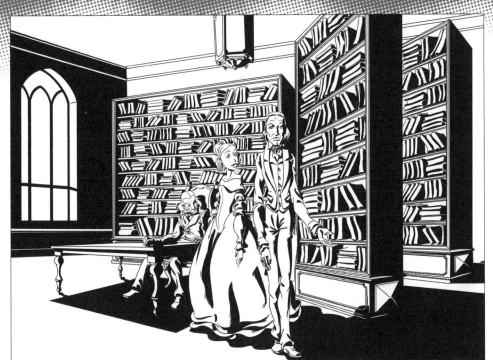

2.

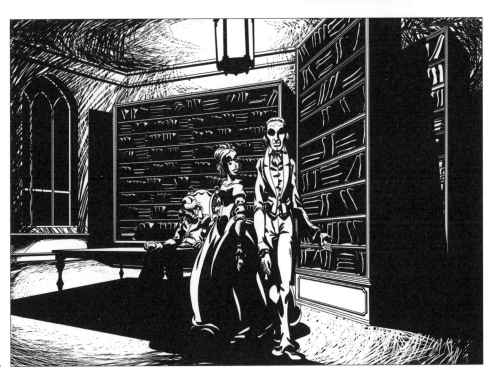

3.

# A HORROR STORY PAGE

Comic art is about more than just individual images! A real comic artist tells a dynamic story through a sequence of panels. This exercise uses many of the skills you've already learned to put together a complete horror story page. There's more about planning a comic book page on pp.120–1.

**1** Roughly sketch the scene in miniature, with the two figures encircled by spirits rising from the gravestones, and the arch of an ancient tree above.

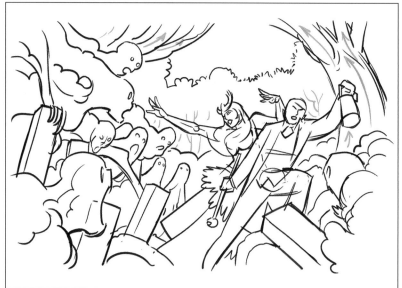

**2** Now, start on the full-size drawing, building the two main figures reaching to the left and right. The cloudy spirits only have their upper halves. The gravestones are at different angles, as they have toppled over with age.

**3** In these finished pencils, areas of different shading are indicated. The vampire and enchantress stand at dramatic angles in front of a dark background, trying to hold back the rising spirits with spells and lantern light. The spirits have their own unearthly light.

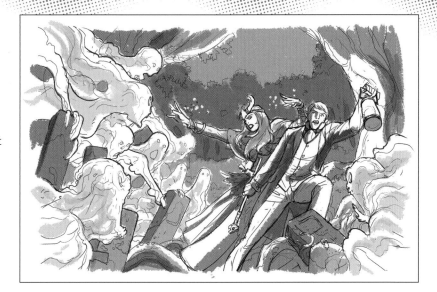

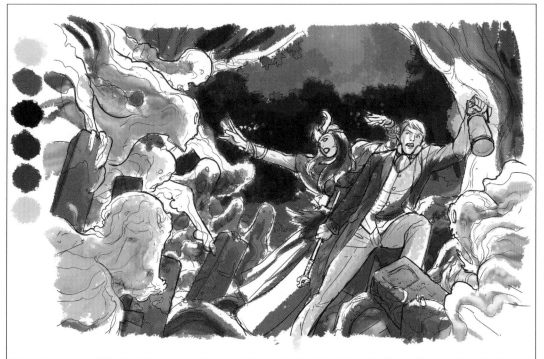

**4** The scene is lit by moonlight, so most of the scene is painted with cool, bluish hues. The lantern light is yellow and illuminates the young vampire, bringing out the red of his waistcoat.

**5** In the final picture the spirits are painted with bubbling patterns. They arise from the graves like ocean waves. Only the unlikely heroes can stem this dark tide.

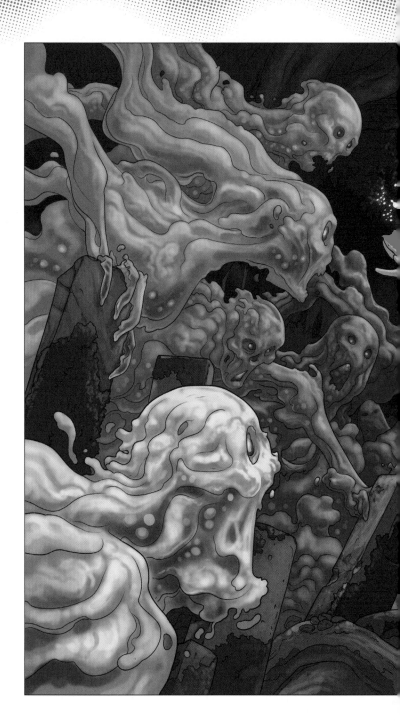

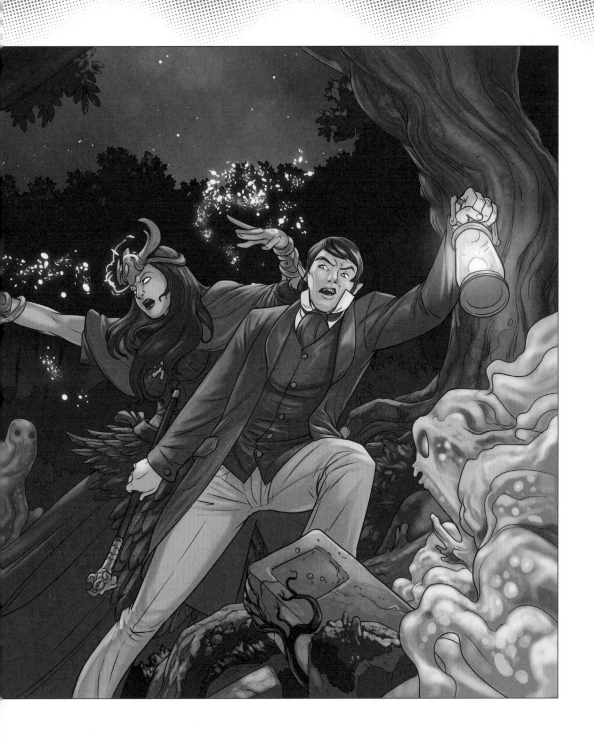

# PRACTICE

# THE NEXT LEVEL

In this last section we will show how you can take your comic book art to the next level. To do this, you will want to create eye-catching pages, master the art of the speech balloon, write engaging plot-lines, and finally, top it all off with a masterful cover. Here, you can see how to plan a successful comic book page.

◄ This story shows the hero Mammoth in conflict with evil genius Automator. Start with a thumbnail—a small, rough plan of the comic page. A variety of views, from wide-open shots to close-ups, should be used on the page to make it exciting. There are six panels leading to the big event, when Mammoth breaks free. The action should lead your eye toward this point.

The first panel is an **ESTABLISHING SHOT**, to set the scene in downtown Capital City, showing Automator's machine approaching Mammoth.

Pale-blue ruled **PERSPECTIVE LINES** help the artist to draw buildings at the correct angle.

Panel 2 is a **MEDIUM SHOT** from Automator's point of view, showing all of Mammoth's body.

Panel 3 is a close-up of the evil villain.

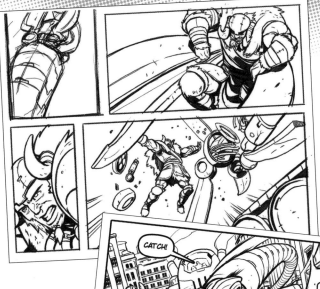

➡ Mammoth looks like he's going to be squashed by the machine. The view of the hero gets tighter too, so you can feel the pressure he is under, and see the struggle in his face.

⬅ Even when there's a lot to draw, don't forget to allow space for the characters' dialog. Word balloons can take up about a third of the panel; they are usually placed along the top.

➡ The finished, inked page has a lot of drama, with every panel pulling you through the story. The shaded areas have been filled in black. Extra background detail has been added to some panels, and some motion lines, but not so much that it distracts from the main action.

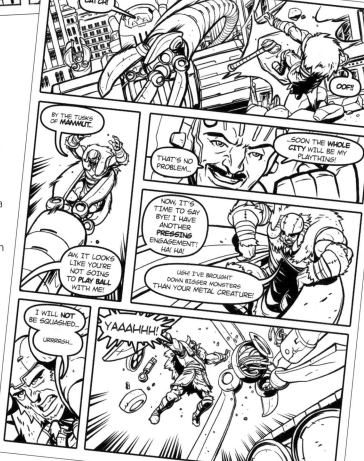

# WRITING AND SPEECH BALLOONS

Your comic book heroes and villains may not say much, so make their words matter!
With some well-placed speech bubbles and clever use of dialog, you can make the action
and words leap off the page.

⬆ Comic books use word balloons to hold dialog.
Though you can vary the shapes, balloons tend to
be oval, with a tail from the balloon pointing toward,
but not touching, the mouth of the speaker. Words
are usually in capital letters.

⬆ Spoken words, like the action on the page, should
be read from top left to bottom right, so think ahead
when you place your characters in a panel. Don't have
their word balloons crossing! Above is an example of
what NOT to do.

⬆ Be sure to allow enough room for the talking.
Try not to cover up the characters with word
balloons!

The quays are no safe place to wander at night.

⬆ You can add a caption in a box to set a scene.

YOU SNEAK ROUND THE BACK.

I'M NOT SURE I CAN TRUST GOLDEN LOTUS.

NOCTURNA, GET DOWN!

HERE COMES SALAMANDER! LAY LOW! HE WON'T SUSPECT A THING!

YOU EXPECTING SOMEONE *ELSE*? THE SURPRISE IS ON *YOU*!

⬆ Word balloons can be different shapes for different expressions:

• A dashed border for whispers.

• A cloud shape for thoughts.

• A starburst for shouts or screams.

⬆ When writing speech, use lightly ruled lines with some space between them. Write in the dialog, then use an ellipse template or curve tool, if you have one, to draw the balloon border.

⬆ Write in neat capitals and leave a border around the words inside the balloon. A technical pen is good for this. You can use a thicker pen to write bolder words for emphasis.

Finally, remember that comics are a visual medium. While words matter, don't forget to show your characters expressing themselves with their actions, too!

# THE PERFECT PLOT

When it comes to planning an entire comic book story, you'll want a narrative that keeps your readers hooked from start to finish. Here are a few tips to get you started.

### ACT 1. THE SET UP

Characters are introduced and a threat appears. The first part of your story introduces the setting and main characters before something dramatic happens to lead your heroes into danger.

Give the villains a good reason to cause trouble—jealousy, revenge, a troubled past, or a craving for something they don't have.

### ACT 2. THE CONFRONTATION

The hero investigates and ends up in danger. The villain should appear to be a genuine threat. Heroes often lose the battle on a first attempt and have to improve or discover a new way to defeat their foe. This provides a chance for **CHARACTER DEVELOPMENT.**

### ACT 3. THE RESOLUTION

The hero finds a way to escape and save the day. While planning the set-up, think ahead to how your hero will escape. Don't make it obvious—say, by smashing her way out. Have your hero use her brain. The hero, and possibly the villain, should have learnt something new by the end of the story.

### TO BE CONTINUED!

Of course, you could always end with a **CLIFFHANGER...** and hold off Act 3 till the next issue!

# COVER UP

**A front cover needs to grab the attention of a potential reader and give a clue to the excitement inside. Here are the essential elements of a successful cover.**

You don't always need words on the cover, but in this case, Quester's quote adds to the drama.

Your comic will need a title. Usually this will be the name of the lead character or team. Take time designing an eye-catching logo.

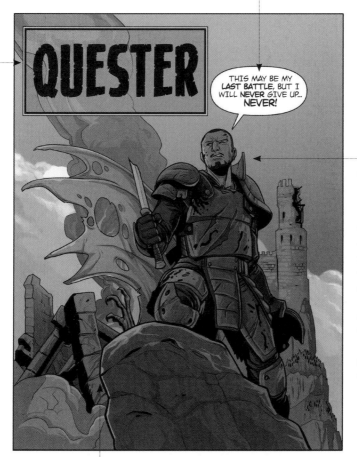

An amazing portrait of your story's hero or a dramatic scene with the hero struggling to survive works well. The image should make readers want to know more— who is this hero? How will he escape certain doom?

The inked outline is bolder than the lines used for the comic story inside, as if it is a blown-up comic panel.

PRACTICE

## PRACTICE